East Anglia From the Air

Norfolk

Martin W. Bowman

AMBERLEY

First published 2014

Amberley Publishing Plc
The Hill, Stroud
Gloucestershire, GL5 4EP

www.amberley-books.com

Copyright © Martin Bowman 2014

The right of Martin Bowman
to be identified as the Authors of
this work has been asserted in accordance with the Copyrights,
Designs and Patents Act 1988.

ISBN 978 1 4456 3362 6
E-BOOK ISBN 978 1 4456 3374 9

British Library Cataloguing in Publication Data.
A catalogue record for this book is available from the British Library.

Typeset in 10pt on 13pt Celeste.
Typesetting by Amberley Publishing.
Printed in the UK.

THE SORTIES

INTRODUCTION

It is difficult to wax lyrical when snow is pelting down outside your window and the February doldrums are threatening to stifle enthusiasm for living. Christmas has come and gone and January is the time to think about holidays. Botswana and South America beckon; what's warm and inviting about North Norfolk and the coast? When it comes to holiday brochures, even the most gifted travel agent would be hard-pressed to compare Norfolk with them, despite the county's 'big sky', 'golden sandy beaches' and 'eclectic mix', but they do try – very hard – waxing lyrical with descriptions like 'a heady mix of beachside action tailor-made for those picture postcard holiday memories'. The only African and Latin American wild game on offer locally can be found at Banham and Cromer zoos, along with some Asian animals, such as the tigers at Thrigby, but photographically – especially from the air – Norfolk offers much. The coast is more beautiful in winter and certainly quieter, so a week-long sojourn near Wells, Salthouse, Mundesley or elsewhere is quite appealing. All along the eastern shores there are bustling, commercial resorts along with quiet Victorian ones, and there are also the flint-walled villages, often stranded and cut off by dunes and salt marshes, which are constantly being reshaped as new land is won from the North Sea.

My home county is often accused of being a backwater, cut off from the rest of civilisation as a result of poor roads (currently being addressed) and interminable train journeys. Many feel that this is a good thing. An improved A11 certainly gets you 'there' quicker but it also brings with it an added burden on Norfolk's rural and urban arteries. Norfolk communities are often perceived as being solitary and parochial, and interlopers or 'furreners' are not welcome – unless they are tourists with ready cash to spend in the Norwich shopping malls and in towns like Wroxham and Wymondham. They also find a ready welcome at the coastal resorts that stretch from The Wash to the Waveney, and trippers often hire out boats on our world-famous Broads. There are seven rivers and sixty-three Broads, mostly less than 13 feet deep. For many years the broads were regarded as natural features of the landscape. Dr Joyce Lambert proved in the 1960s that they were peat excavations that had been flooded during the medieval period. Local monasteries used the land as a turbary during the Middle Ages, and sold the peat on to cities such as Norwich and Great Yarmouth – 320,000 tonnes were produced each year. This practice ended when the pits began to flood as a result of the rising sea levels.

If golf is your game Norfolk has more than its share of fairway fun, with almost as many golf courses as there are wartime airfields.

Changes to our way of life – and leisure – are rarely well-received. Inveterate and well-established names like Lotus, the North Norfolk Railway and the world-famous Norwich Union we like, but not 'The Poppy Line' and 'Aviva' (which sounds to me like a bus company), under which names some marketing whizz-kids inexplicably reinvented them. Even Cromer crabs are under threat.

Norfolk 'dumplings' can take a dim view of everything from holiday homes, Londoners and anyone from Ipswich.

Electricity pylons stalking our land like mutating transformers are hardly photogenic, and who wants a crop of wind-powered pylons with their gigantic propellers in their viewfinders, either at 2,500 feet or when ankle-deep? They spoil the countryside just as easily as row upon row of ghastly traffic cones, while yellow lines ruin our cobbled thoroughfares and well-kept garden frontages. Photoshop can come to the rescue but sometimes the sign on the door says 'Closed' and it is really down to you.

Above all else, Norfolk is inextricably entwined with the North Sea, where coastal settlements hug the shore like limpets. It is a story of frontiers lost and won in the timeless battle with the waves. Flat as a tabletop in places, the pastures give way to low-lying land and sandy, shingle and pebble beaches and dunes, all of which suffered greatly in the Great East Coast Flood, which began on the evening of Saturday 31 January 1953. Waves 8 feet tall pounded the coast, and 307 people perished between the Humber and the Thames while 32,000 were forced to flee their homes. Salthouse suffered terribly, and there is still a risk when full-moon spring tides and gales threaten. Roadside notices in Salthouse champion local crab, cockles, shrimps, whelks and samphire while signs warn visitors of the danger of unexploded bombs!

The county's coastline has always offered wonderful havens for nature lovers and twitchers who watch birds on the wing – either on plentiful mudbanks where the shining creeks meet the sea and bird life thrives, or at RSPB bird sanctuaries with their hides. At intervals, the tranquillity is shattered by 'Eagles' overhead (USAF F-15s!) and RAF jets roaring out of Marham. It reminds one of the delightful 1950s film *Conflict of Wings*, which starred John Gregson and Muriel Pavlow. In the film, they decamped to Ludham on the edge of the Broads, where 'Norfolk' locals (played by actors with Devonian accents mixed in with contentious 'Broad Norfolk' dialects) are up in arms when the RAF want to use a bird sanctuary known as the 'Island of Children' as a firing range for their Vampire jet fighters. Today the east coast is still populated by several bombing ranges and they are used often by military aircraft. These transitory jets, and the graceful gliders and slower hang-gliders, can pose a potential hazard while carrying out aerial photography. It is well to remember that the glider fraternity does not carry radio, and pilots of powered aircraft rely on their radar, air traffic controllers (who use phrases such as 'be aware that in your vicinity' and 'at your discretion'), and their own 'Mark One Eyeball' to maintain a look-out.

Two of the coastline's most notable features are the nature reserves at Cley (pronounced Cly) and at Blakeney Point, whose reserve dates from 1912. Except for the harbour channel leading down to Wells-next-the-Sea, the entire 12 miles of coast between Overy Staithe and Blakeney forms the Holkham National Nature Reserve, the largest coastal nature reserve in England, covering almost 10,000 acres of unspoiled dunes, beaches and salt marshes. A lane leads down from the village of Morston to a tidal creek, which runs almost dry at low tide. In 1973 the National Trust purchased 540 acres of Morston marshes, together with Morston Quay where boats can be launched to take visitors to the bird sanctuary at Blakeney Point and to see the seals basking on the sandbanks.

Brick villas interspersed with chalets and caravan parks now shelter behind concrete sea walls or shingle banks on the foreshore with sand beyond, stabilised by groynes; but, like King Canute, we cannot command the waves. At places like Happisburgh (pronounced 'Hazeborough'), the road goes nowhere, because the sea has consumed large chunks of clifftop like a ravenous beast, and several dwellings in the front line have since been consigned to oblivion by the authorities. The lighthouse nearby remains a solitary sentinel and even its days are numbered, with the waters predicted to lap around the edifice by 2105.

Seaside spectacle is all well and good but it is from the air that the full majesty of the county unfolds, whether it is the university city of Norwich with its wonderful cathedral and castle; Elm Hill and the meandering River Wensum; or the outlying towns and villages nestling in the far corners of 'Nelson's County'. These stretch to the holiday havens at Great Yarmouth, Hunstanton and Sheringham, and to Cromer where cars can park on the sea wall facing the sea. From the air and the ground they are unique and unrivalled by any other vista in England, but then I am biased.

My aerial odyssey of Norfolk unfolds with several episodic aerial adventures from airfield hubs in and around the county capital, most often with Roy West in the Piper PA 28, Arrow 3 or PA32 Lance, but occasionally secreting myself in Boeing Stearman, Jet Provost and Yak-52 'camera-ships'. Militarily speaking I have had many enjoyable trips in Army Air Corps' helicopters and even the Lancaster! Feeder flights aboard KLM 'Cityhoppers' transiting between Norwich International and Schiphol in Amsterdam, barely 50 minutes' flying time away, have also provided opportunities for snatched shots after take-off. Sitting in isolated splendour among the clouds in a speeding broad arrowhead aimed at the heart of Broadland and the often treacherous sea beyond, one can view the myriad boating villages that line the route to the 'jigsaw' coastline, as you say 'Bon Voyage' and head for Holland.

Now, *that* country is as flat as a tabletop!

Martin W. Bowman

ACKNOWLEDGEMENTS

Pio Altarelli; Jim Avis; Staff Sergeant Steve Graham AAC; BBMF; Mike Page; and Roy West

BIBLIOGRAPHY

Illustrated Guide to Britain's Coast (Drive Publications Ltd for the Automobile Association 1984)
Reader's Digest Book of the Road (1996)

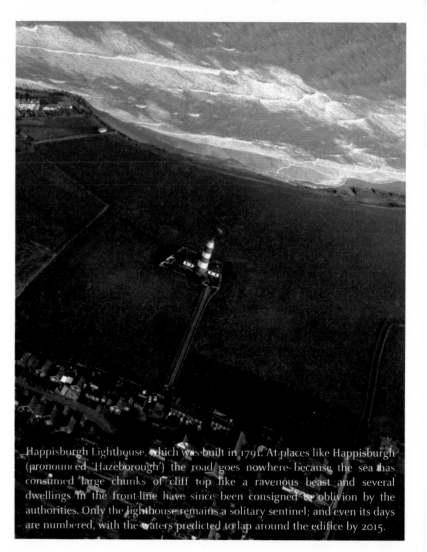

Happisburgh Lighthouse, which was built in 1791. At places like Happisburgh (pronounced 'Hazeborough') the road goes nowhere because the sea has consumed large chunks of cliff top like a ravenous beast and several dwellings in the front-line have since been consigned to oblivion by the authorities. Only the lighthouse remains a solitary sentinel; and even its days are numbered, with the waters predicted to lap around the edifice by 2015.

1

REMEMBER NOVEMBER

Norwich International Airport, built on the site of the former RAF Horsham St Faith, which was deactivated on 1 August 1963.

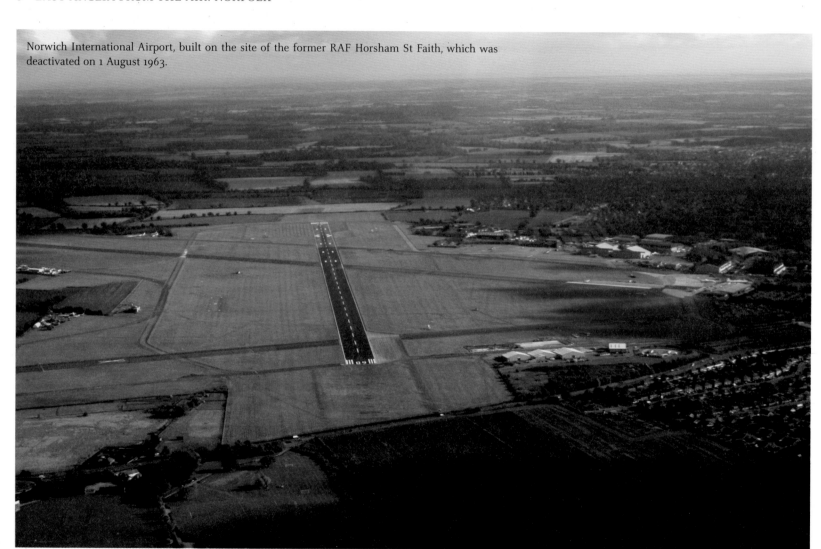

North Walsham.

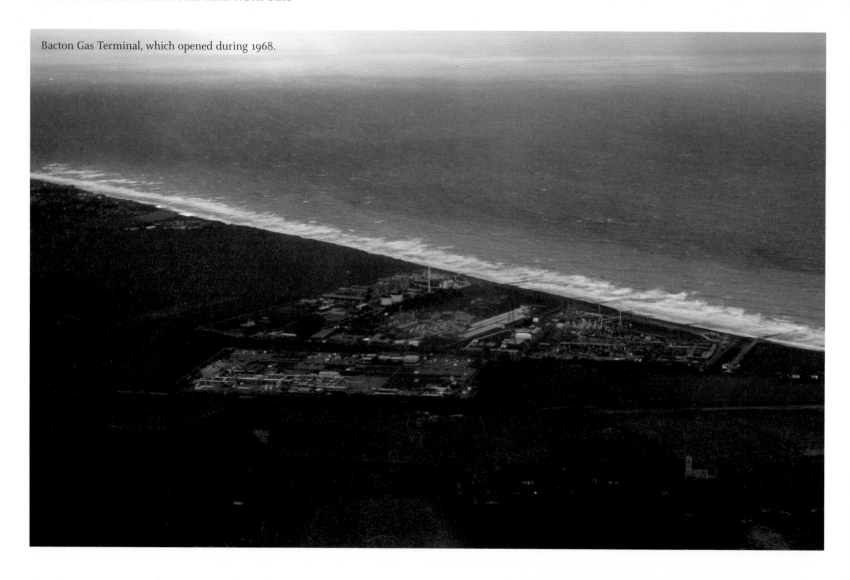

Bacton Gas Terminal, which opened during 1968.

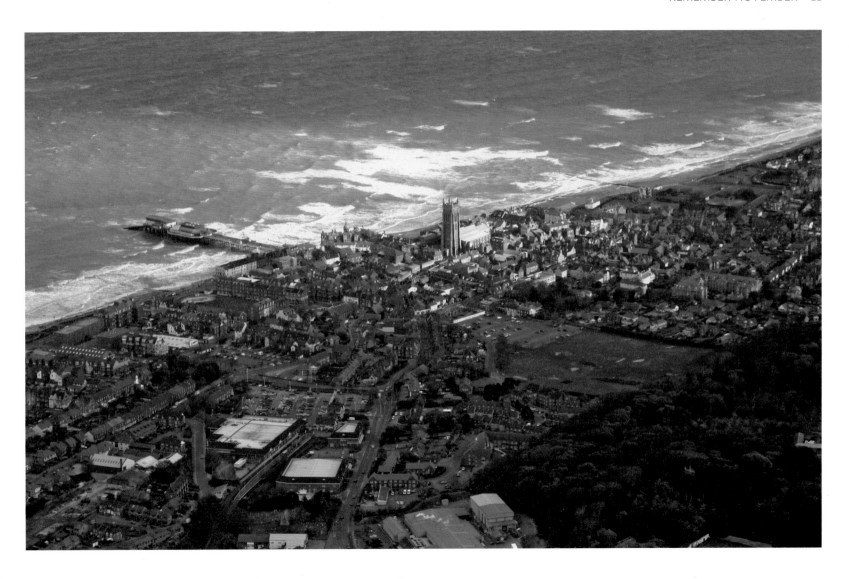

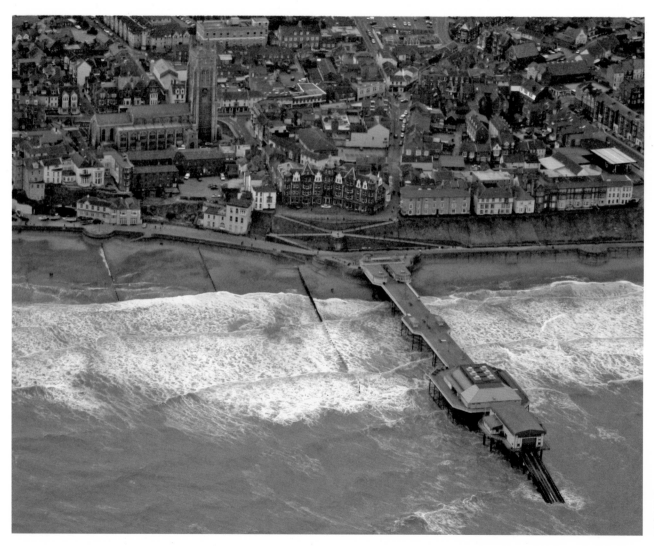

This page and previous: Cromer Pier, which is the home of the Cromer Lifeboat Station and the Pavilion Theatre.

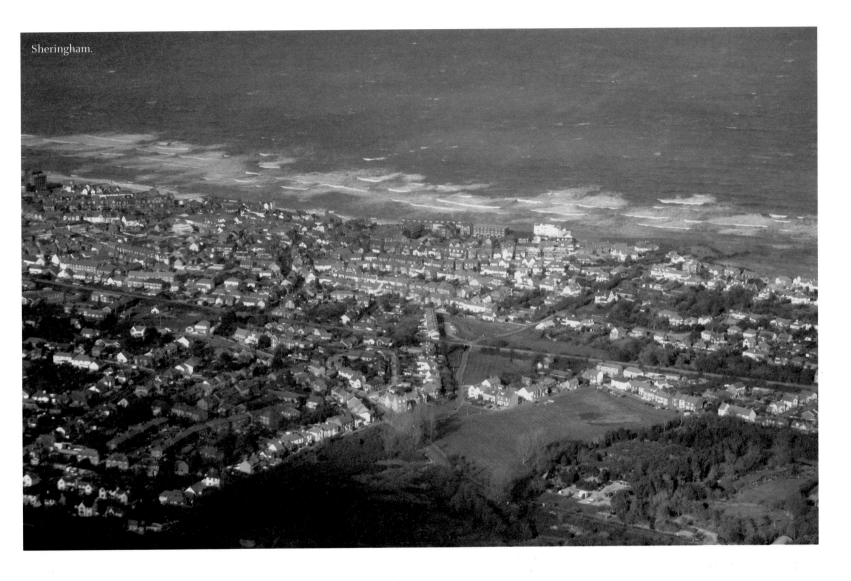

Sheringham.

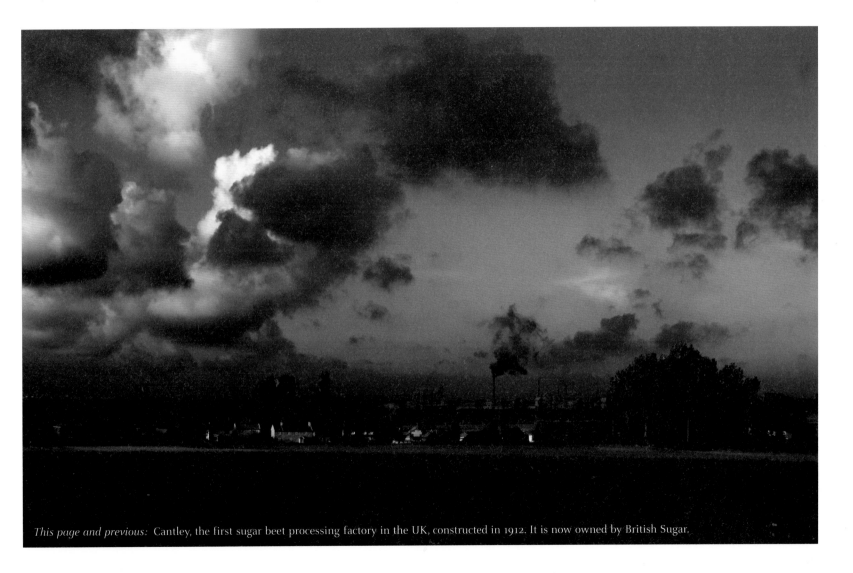

This page and previous: Cantley, the first sugar beet processing factory in the UK, constructed in 1912. It is now owned by British Sugar.

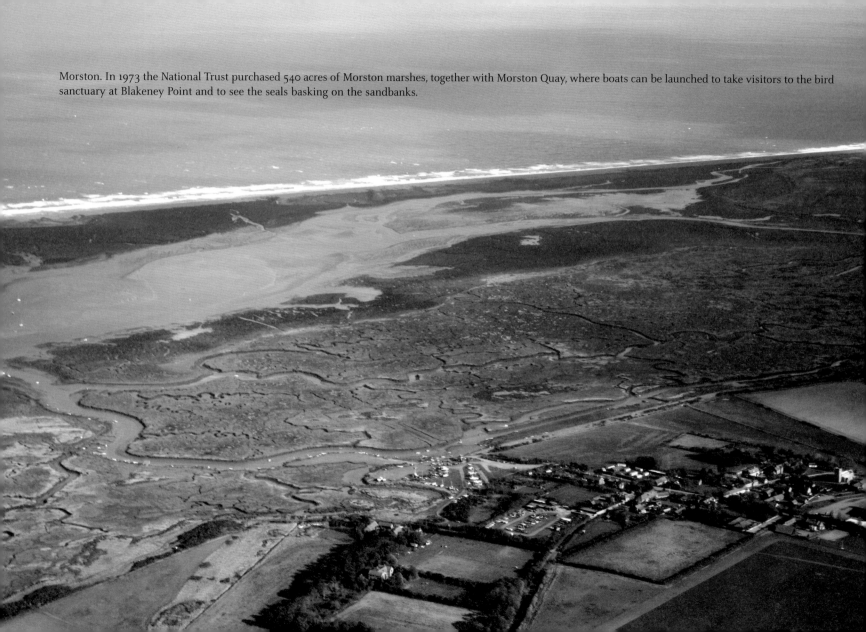

Morston. In 1973 the National Trust purchased 540 acres of Morston marshes, together with Morston Quay, where boats can be launched to take visitors to the bird sanctuary at Blakeney Point and to see the seals basking on the sandbanks.

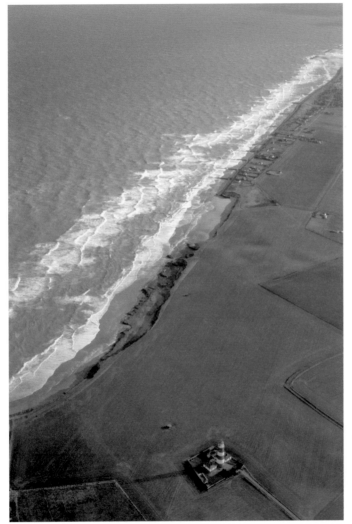

Happisburgh
Lighthouse.

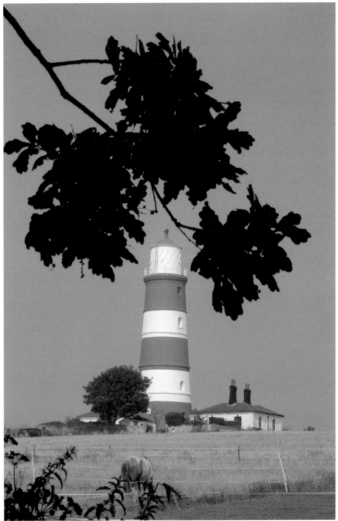

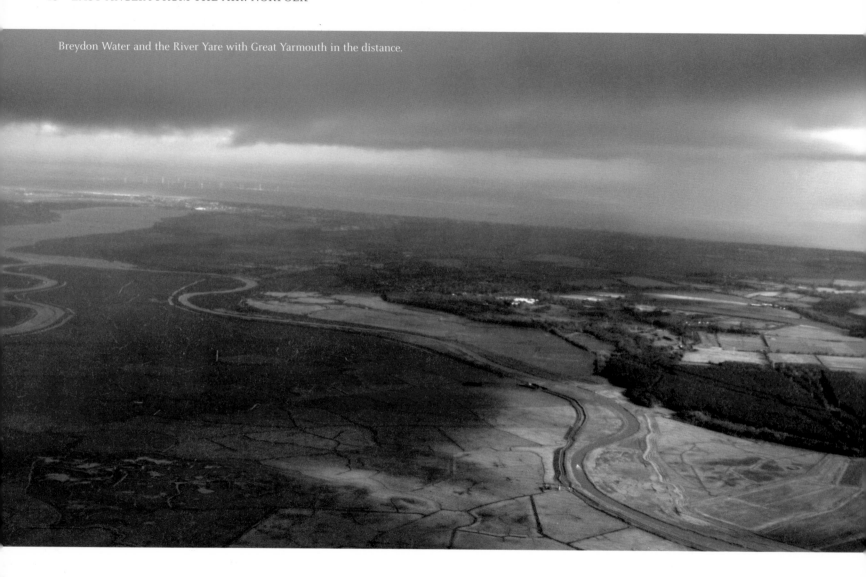

Breydon Water and the River Yare with Great Yarmouth in the distance.

This page: Boating on the Broads.

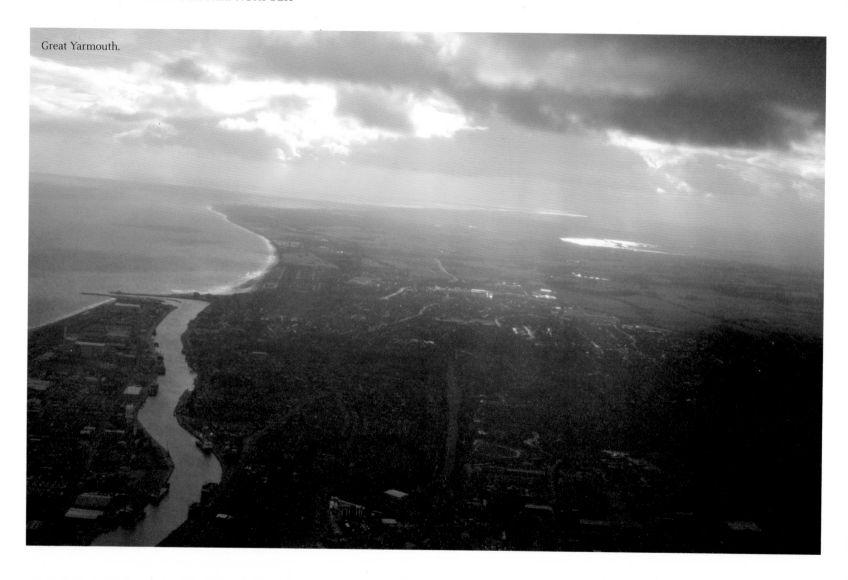

Great Yarmouth.

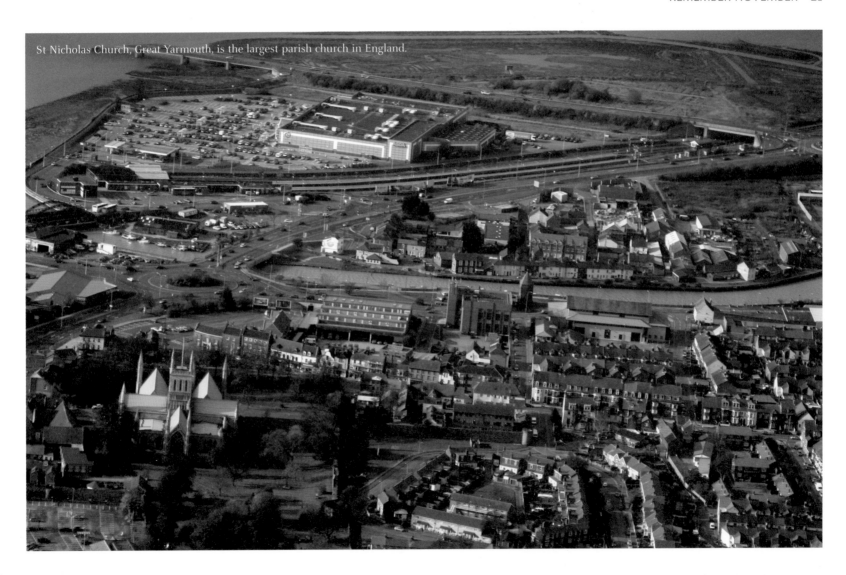

St Nicholas Church, Great Yarmouth, is the largest parish church in England.

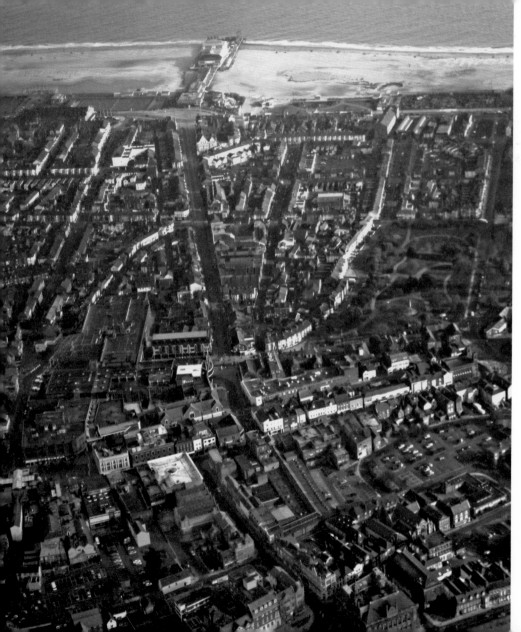

Great Yarmouth and Britannia Pier. The town was once the home for herring fishing boats. The quayside was filled with open sheds where the fish were prepared and smokehouses produced Yarmouth kippers. Great Yarmouth is now a popular seaside holiday resort famous for its 'Golden Mile', a stretch of sandy beach and leisure attractions.

2

COAST AND CARLISLE CALLING

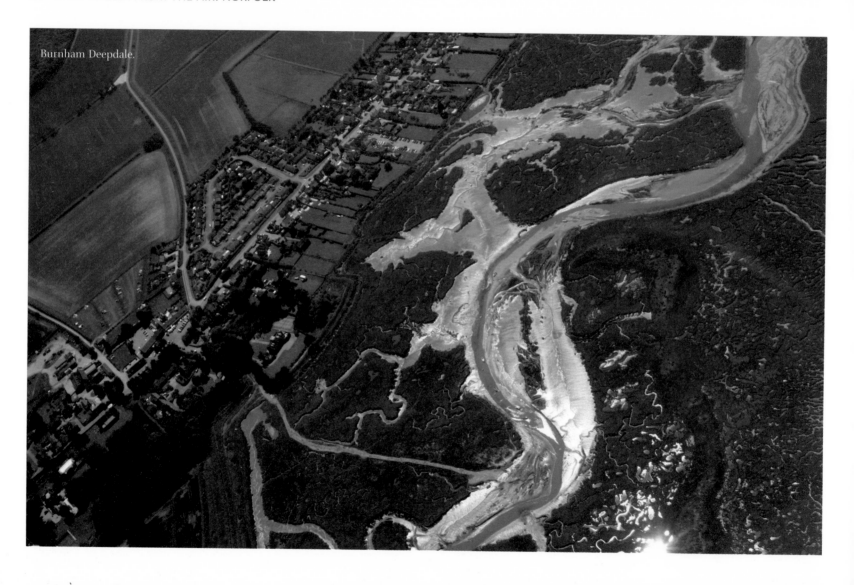

Burnham Deepdale.

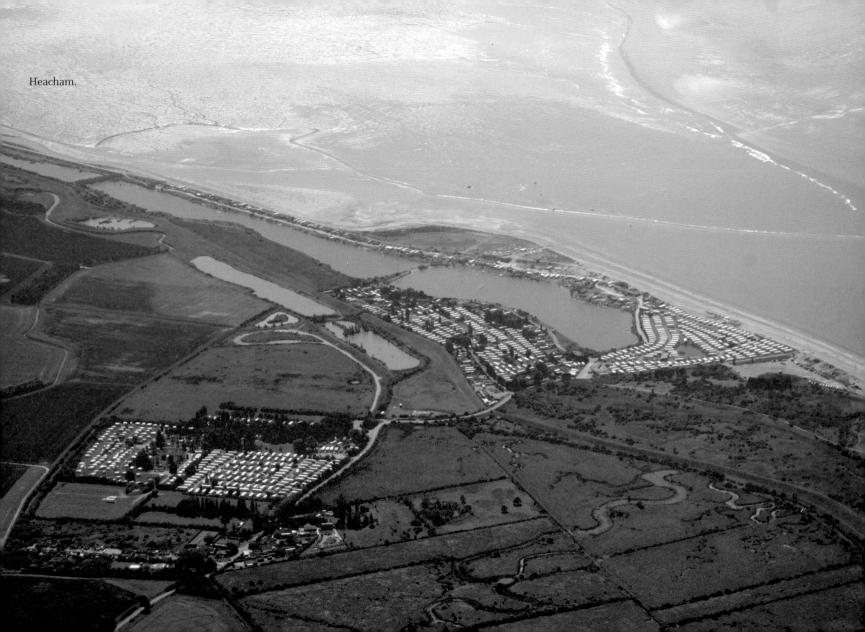

Heacham.

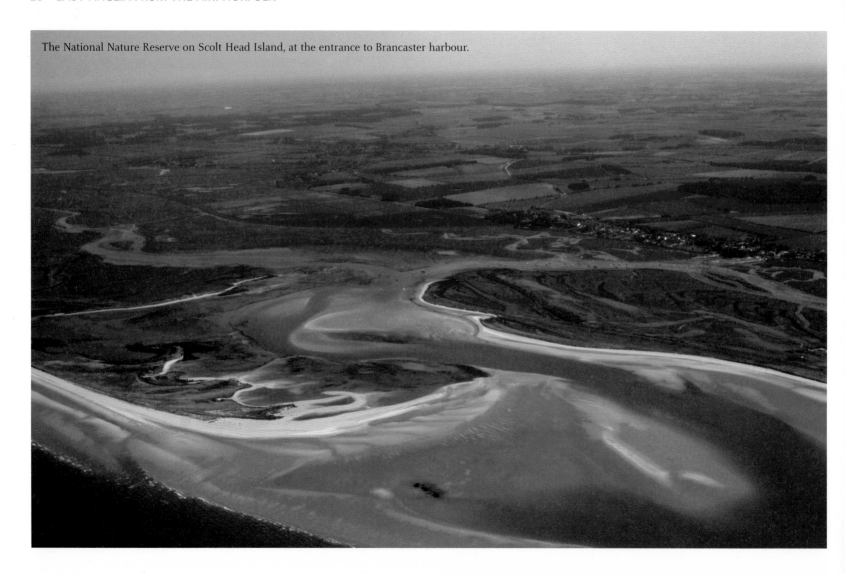

The National Nature Reserve on Scolt Head Island, at the entrance to Brancaster harbour.

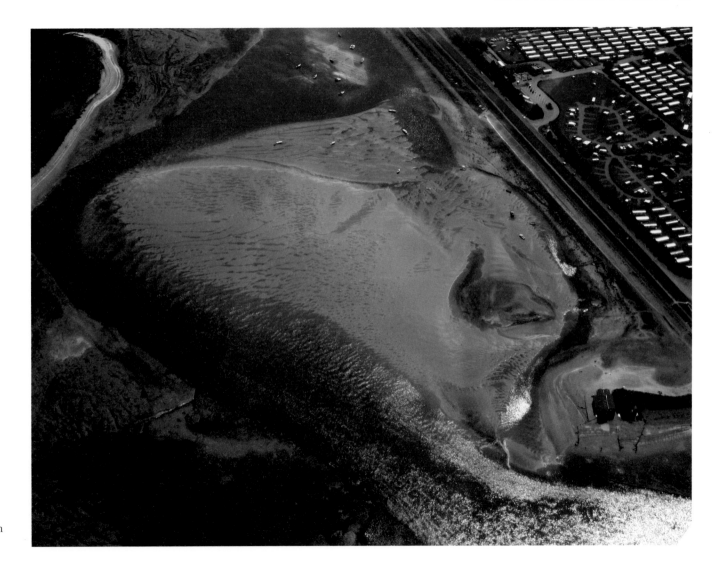

Wells Lifeboat Station
and Caravan Park.

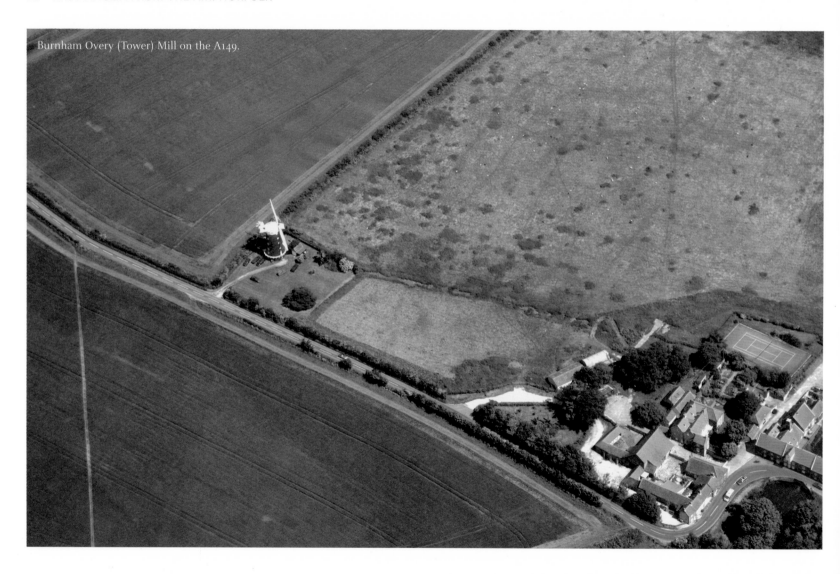

Burnham Overy (Tower) Mill on the A149.

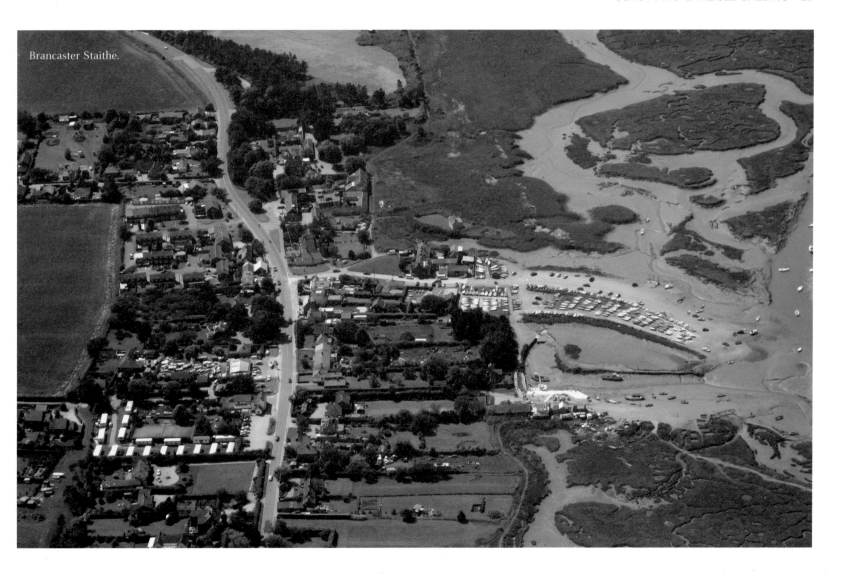

Brancaster Staithe.

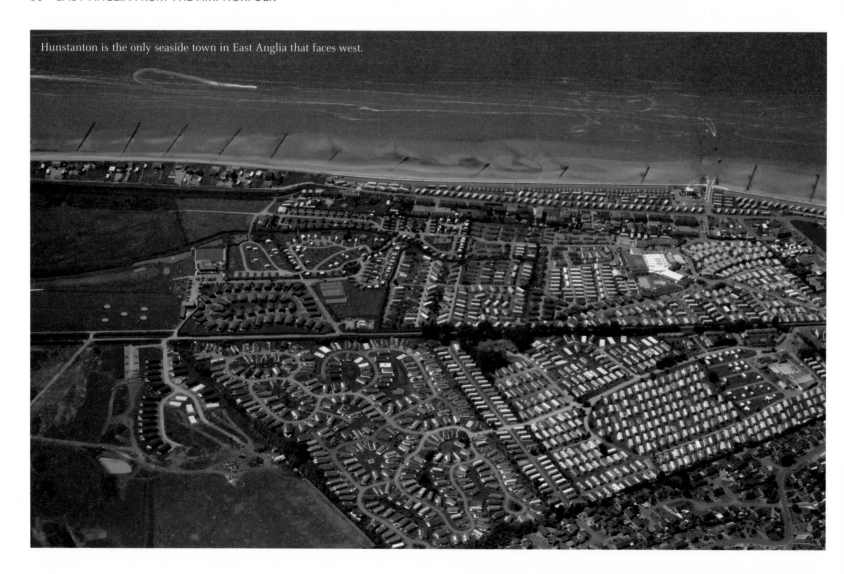

Hunstanton is the only seaside town in East Anglia that faces west.

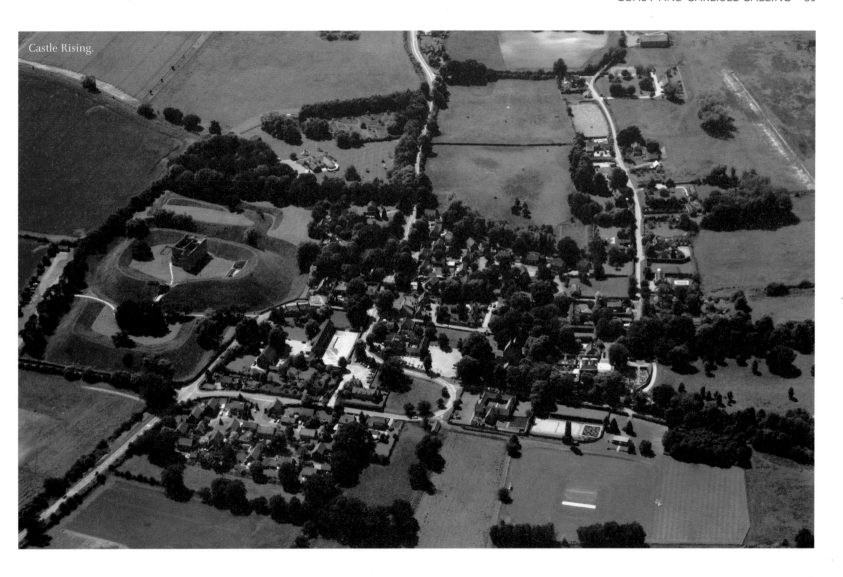

Castle Rising.

The U-bend of The Wash cuts into Lincolnshire and north Norfolk.

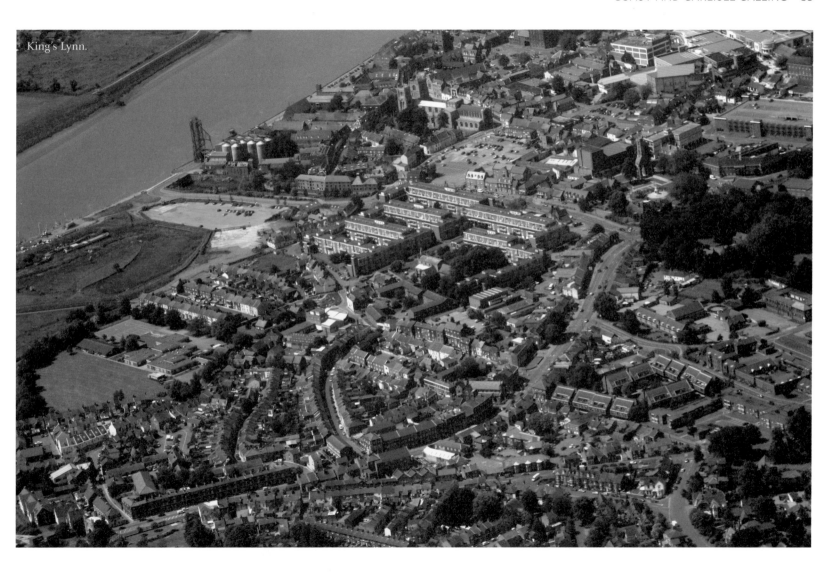

King's Lynn.

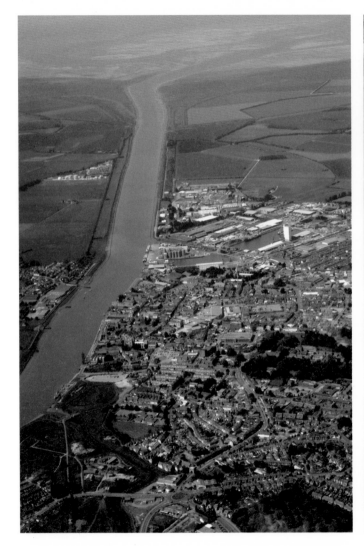

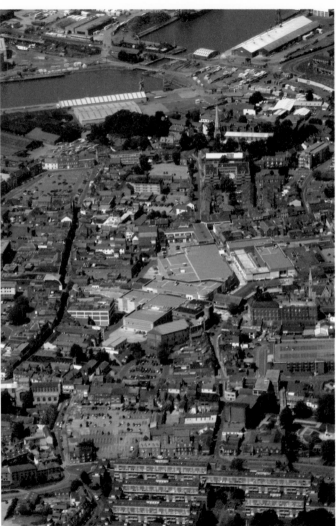

This page: The Great Ouse at King's Lynn.

Opposite: King's Lynn town centre.

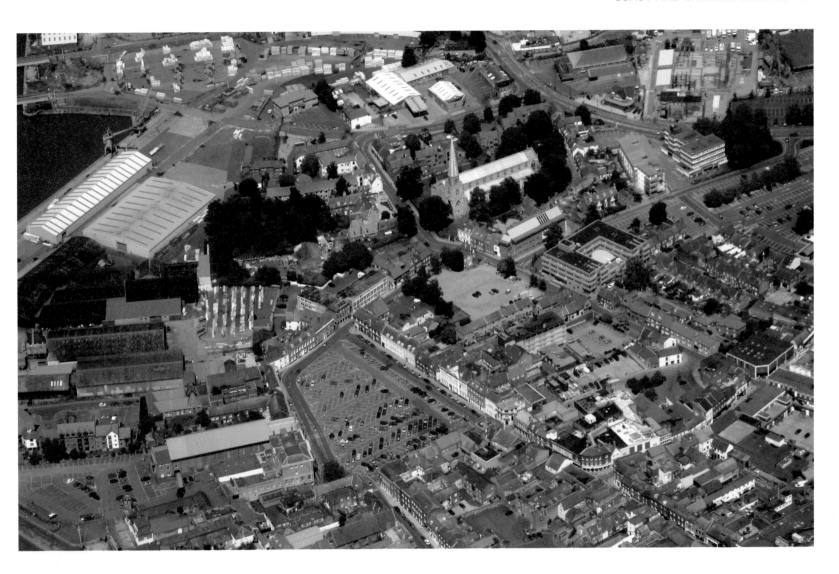

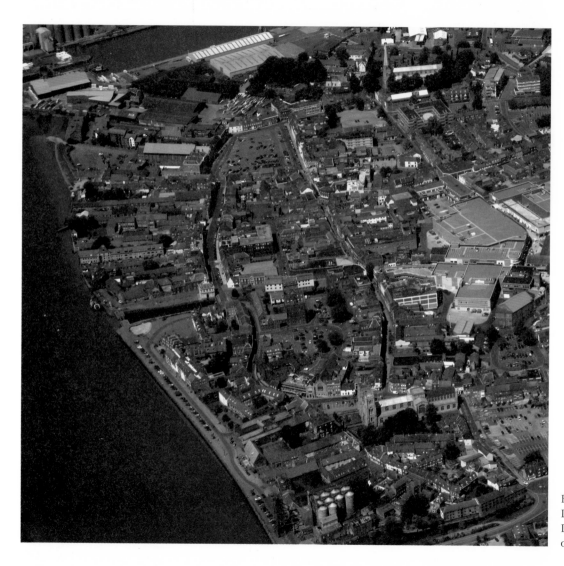

Built on the eastern bank of the Great Ouse, King's Lynn was already a harbour at the time of the Domesday Book. The Custom House (1683) remains on the Purfleet Quay. *Opposite:* The Docks.

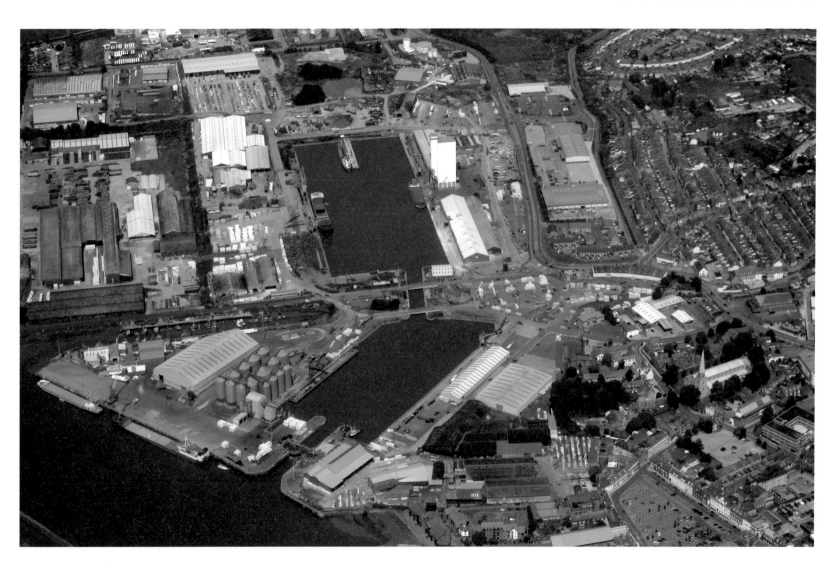

3

FLIGHT OF FANCY

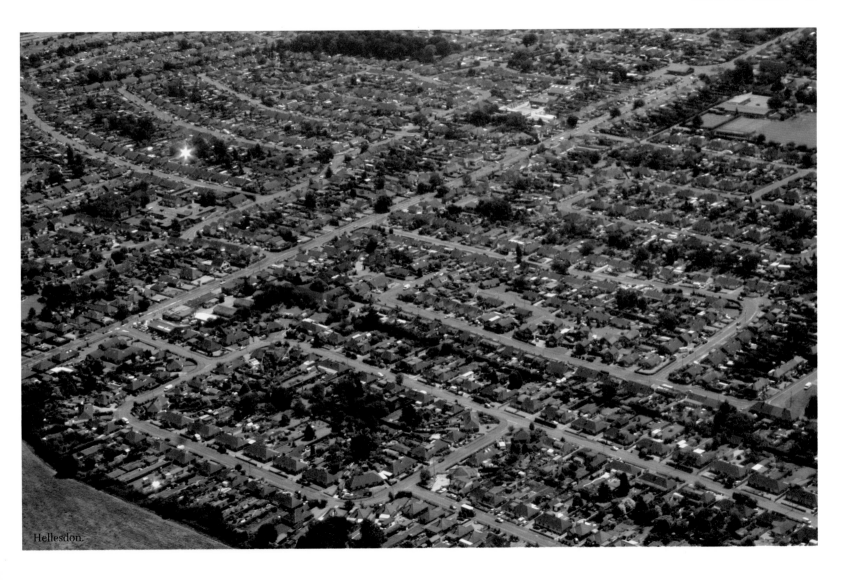

Hellesdon.

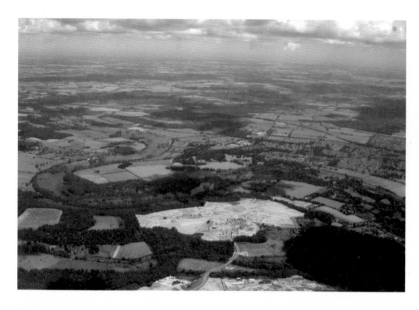

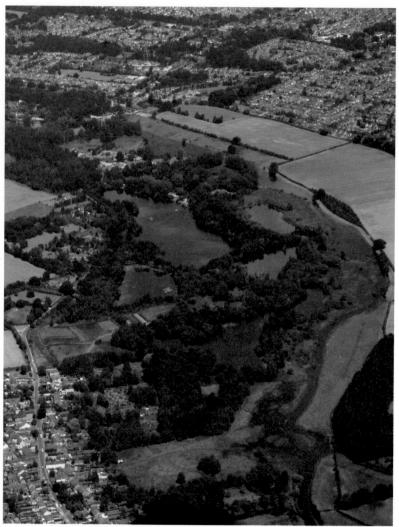

The River Wensum (*above*) and Costessey Pits (*right*). The urban or built-up area of Norwich had a population of just over 213,000. This area extends beyond the city boundary, with extensive suburban areas on the western, northern and eastern sides, including Costessey, Taverham, Hellesdon (*see page 39*), Bowthorpe (*see page 51*), Old Catton, Sprowston and Thorpe St Andrew.

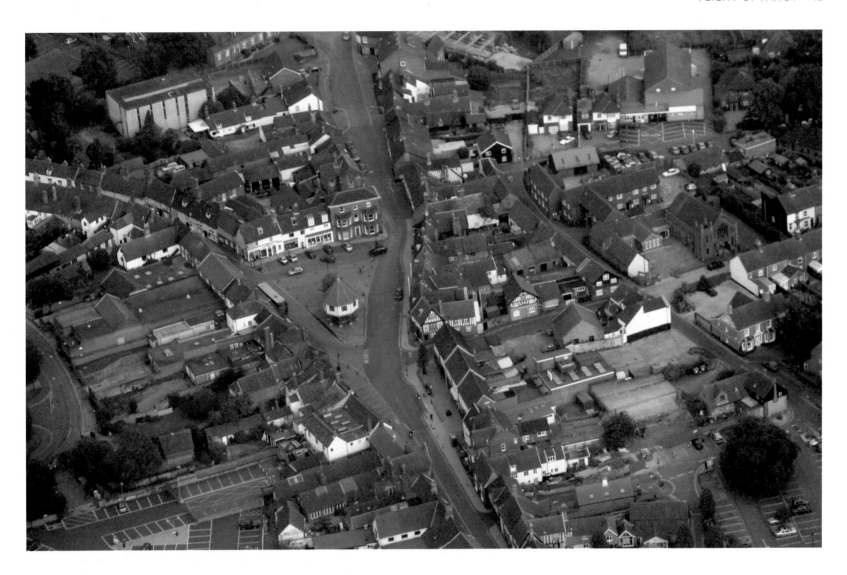

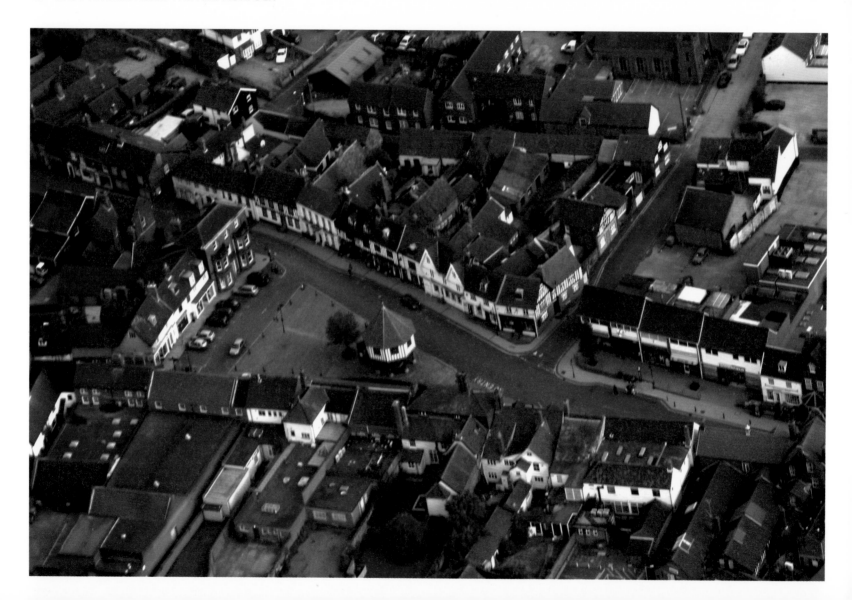

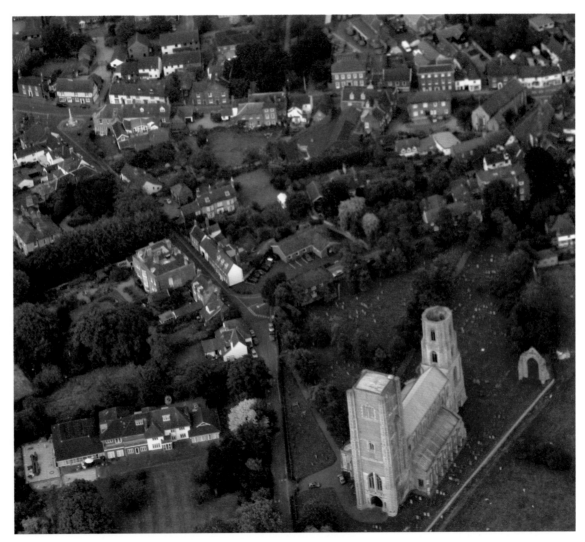

Wymondham is a historic Norfolk market town with its red roofs and the massive towers of the Abbey church, set against green fields of the Tiffey Valley. Begun in 1107, shortly after Norwich Cathedral, the Abbey (*right*) has been adapted over the centuries. The market cross (*see page 41*) is now used as a Tourist Information Centre and is owned by the Town Council. The original building was destroyed in the Great Fire of Wymondham in 1615; the present building was rebuilt between 1617–18 at a cost of £25 7s. The stilted building was like many others (*see opposite*) designed to protect valuable documents from both flood and vermin.

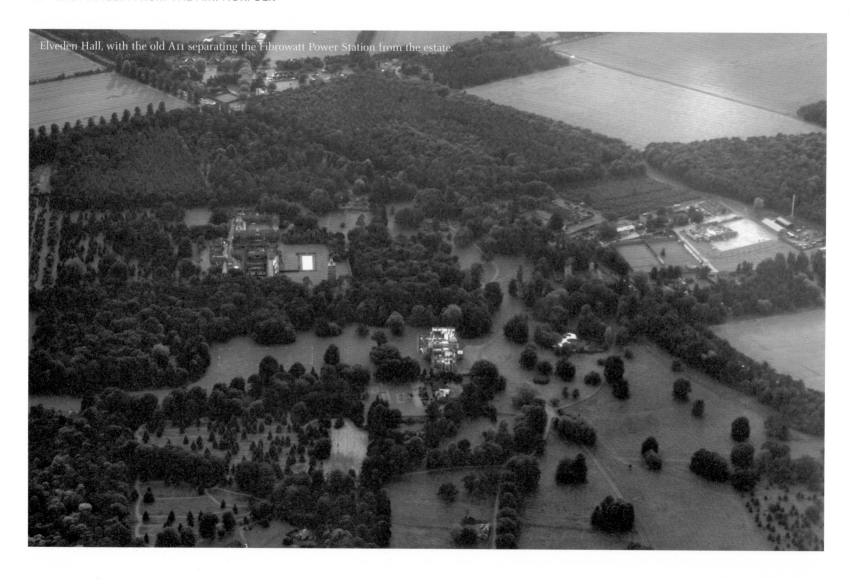

Elveden Hall, with the old A11 separating the Fibrowatt Power Station from the estate.

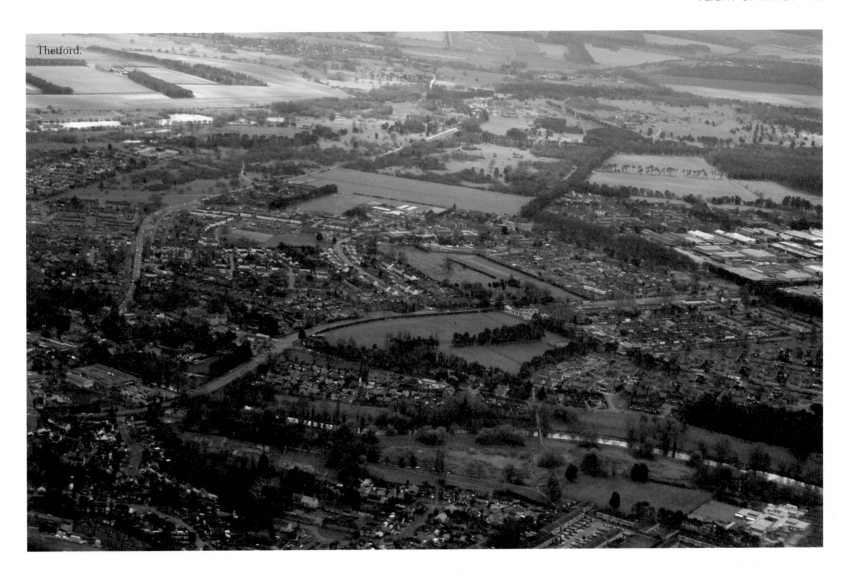

Thetford.

The Fibrowatt Power Station next to the River Little Ouse at Thetford was built to extract heat calories from poultry litter.

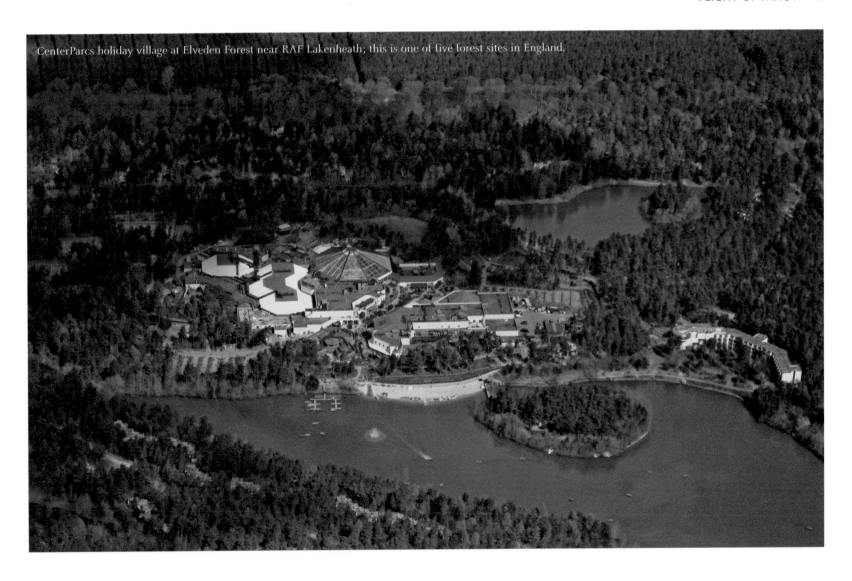

CenterParcs holiday village at Elveden Forest near RAF Lakenheath; this is one of five forest sites in England.

The Red Lodge 24-hour transport café, on the old A11, is actually in Suffolk but for decades has been an important stop en route to and from Norfolk.

Snarl up near Thetford; hopefully now a thing of the past with the dualled A11.

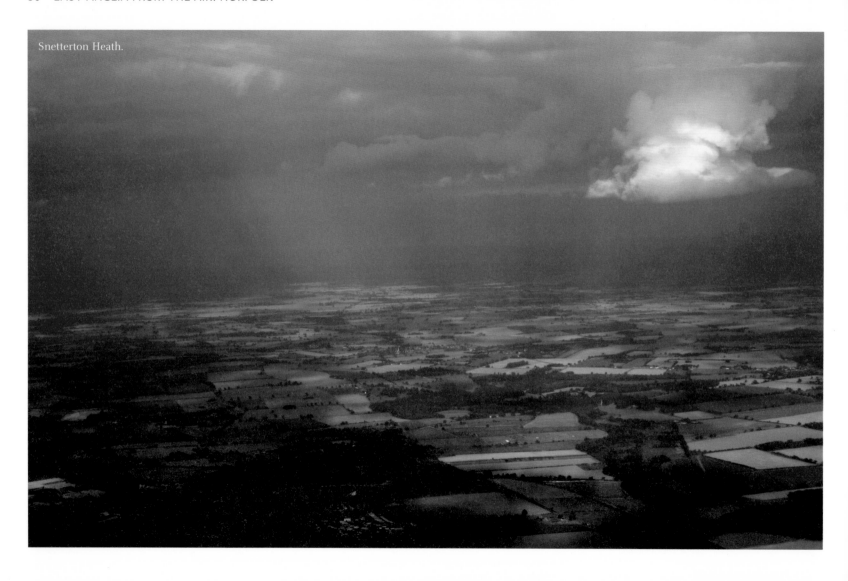

Snetterton Heath.

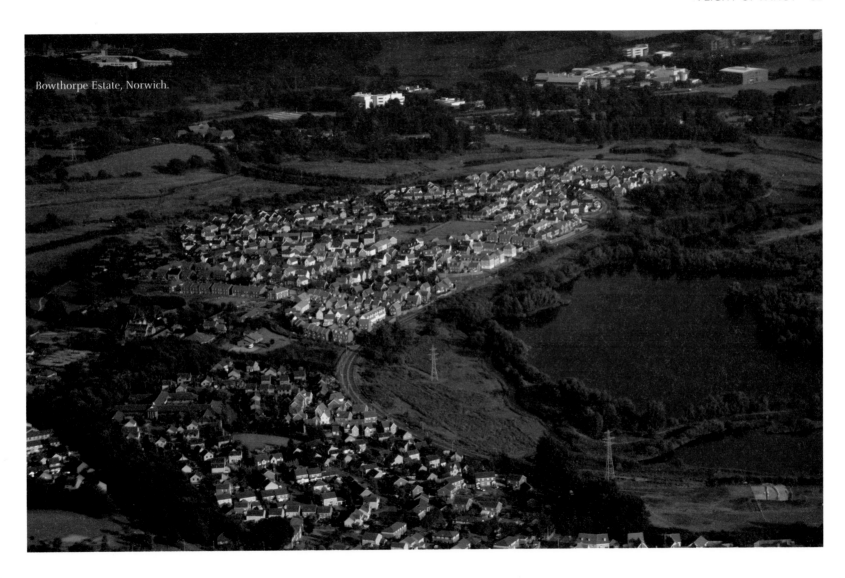

Bowthorpe Estate, Norwich.

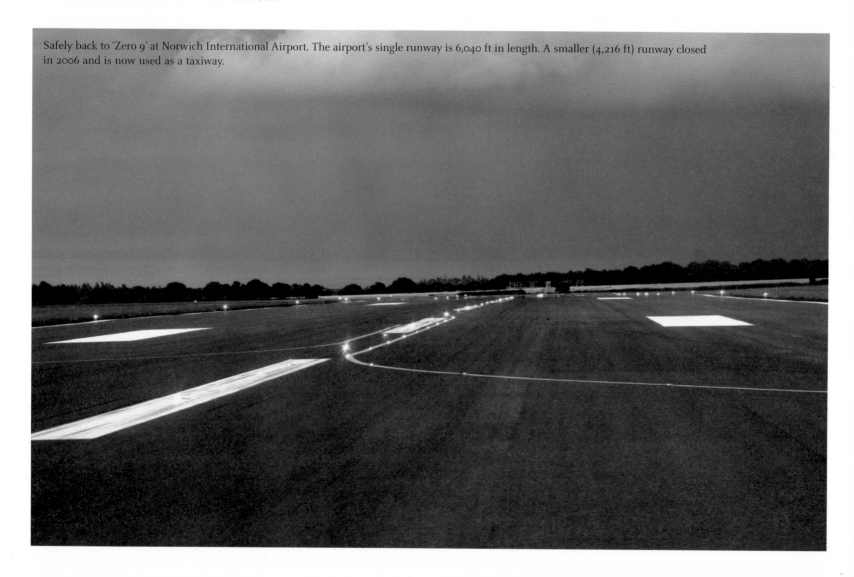

Safely back to 'Zero 9' at Norwich International Airport. The airport's single runway is 6,040 ft in length. A smaller (4,216 ft) runway closed in 2006 and is now used as a taxiway.

4

SEPTEMBER SORTIES

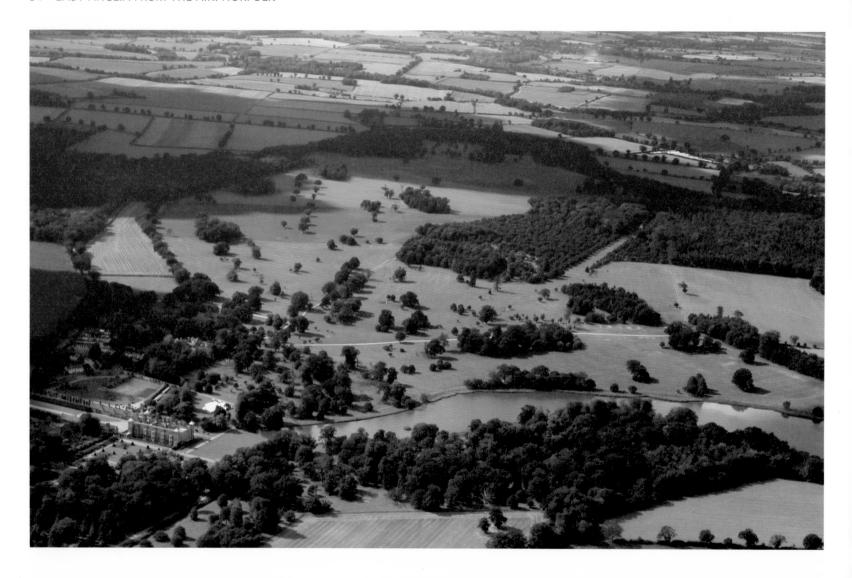

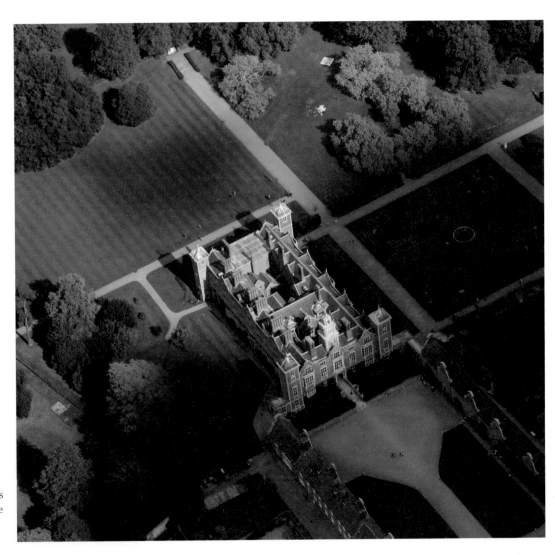

This page and opposite: Blickling Hall has been
in the care of the National Trust since 1940. In the
fifteenth century the Hall was in the possession of
Sir John Fastolf of Caister (1380–1459), who made a
fortune in the Hundred Years War. Later, it was in
the possession of the Boleyn family, between 1499
and 1505. During the Second World War the house
was requisitioned and served as the Officers' Mess
of RAF Oulton nearby. The NT again let it to tenants
until 1960, when the Trust began the work to restore
the house to a style reflecting its history. The house
and grounds were opened to the public in 1962.

Above: Morley Hall. *Right:* Attleborough. The Hall was converted to a hospital under Lend Lease arrangements in the Second World War and was completed in September 1943. The first established unit was the USAAF 77th Station Hospital and this was later reorganised to become the 231st Station Hospital on 6 March 1944. Attleborough's history can be traced back to Saxon times. Sadly, much of the town was destroyed by fire in 1559. It has a fine example of a medieval church with a Norman tower. The traditional industries of turkey-rearing and brush-making still take place. The turkey on the town sign is said to depict the days when Attleborough turkeys had their feet dipped in tar to withstand the journey along roads to the London markets.

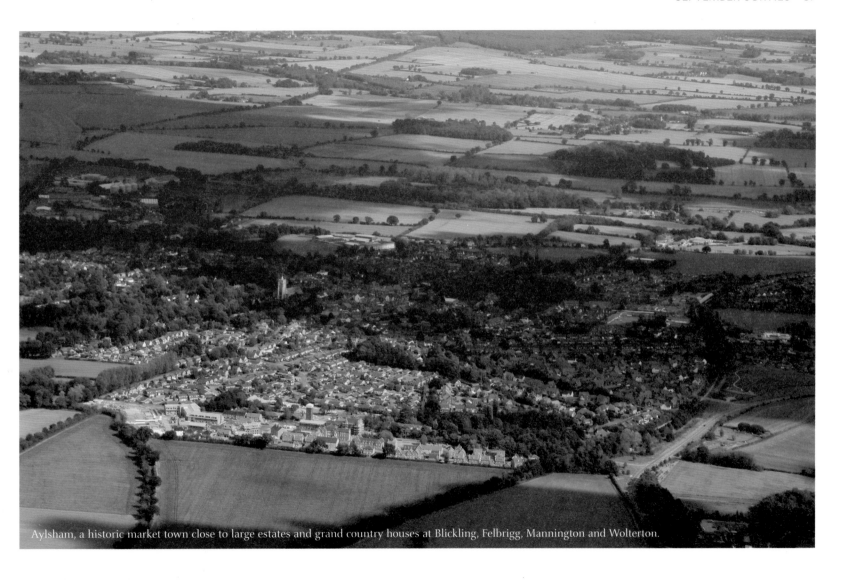

Aylsham, a historic market town close to large estates and grand country houses at Blickling, Felbrigg, Mannington and Wolterton.

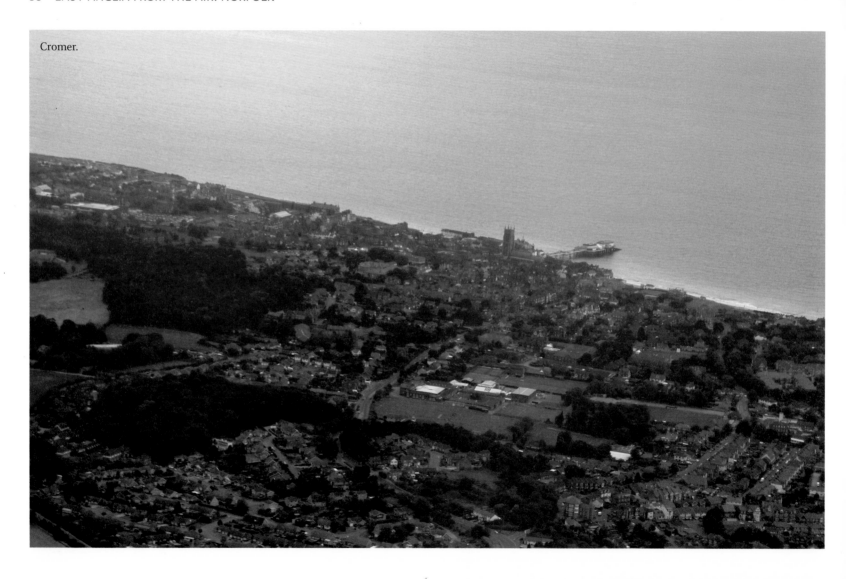

Cromer.

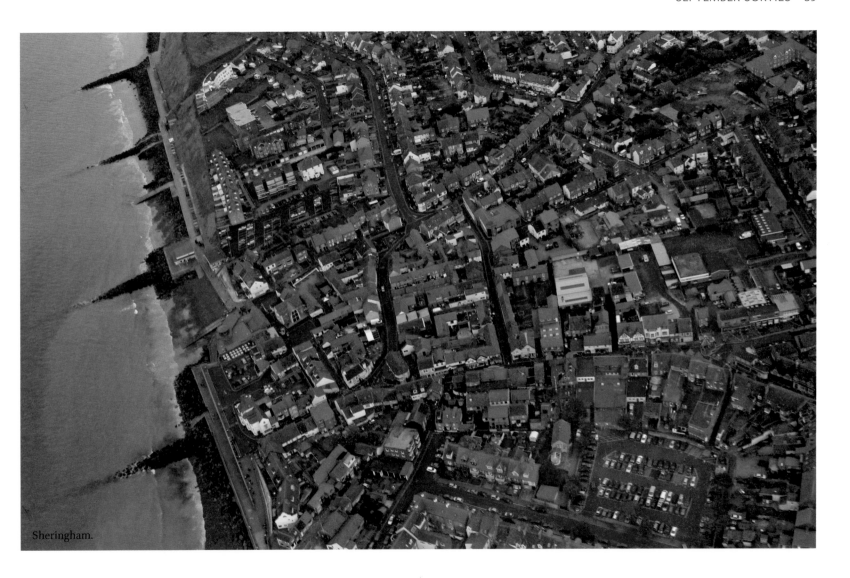

Sheringham.

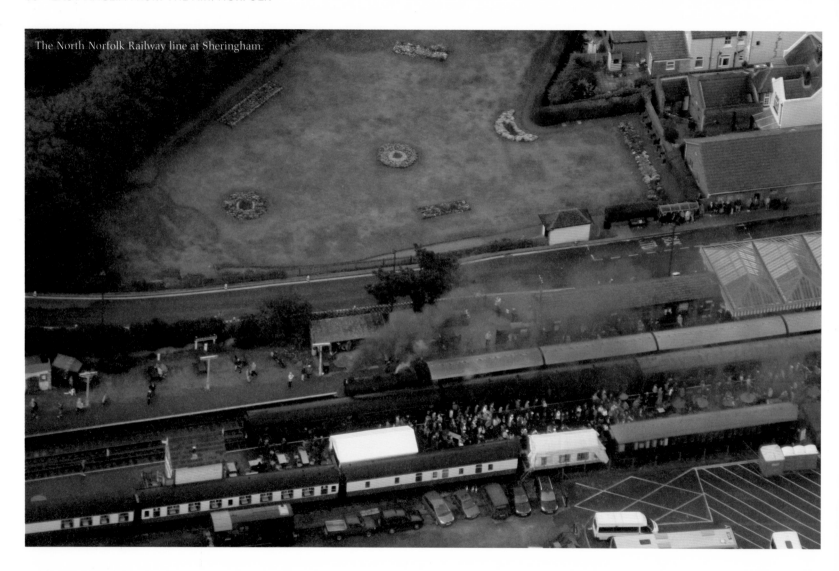

The North Norfolk Railway line at Sheringham.

North Norfolk embraces around 400 square miles; its coastline stretching for 43 miles and much of it, including Weybourne Village (a conservation area) is part of the Norfolk Coast Area of Outstanding Natural Beauty. In typical rural railway fashion around a mile from the village it serves, is the middle station on the heritage North Norfolk Railway Line from Sheringham to Holt. Much bigger than the usual country station, it was built in anticipation of the village's development as a Poppyland resort but the development never happened. Weybourne Mill (*right*) is a fine example of a tower windmill that has been restored but not to its working condition. It was first built in 1850.

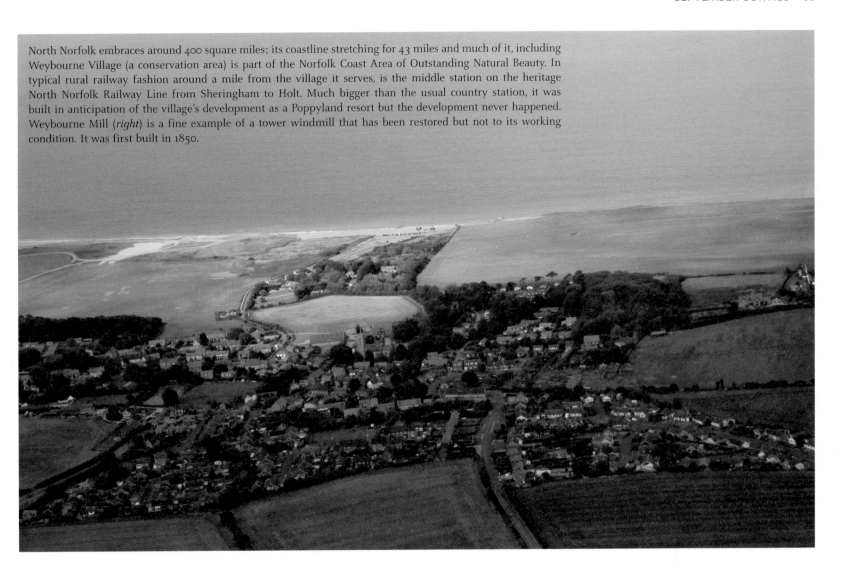

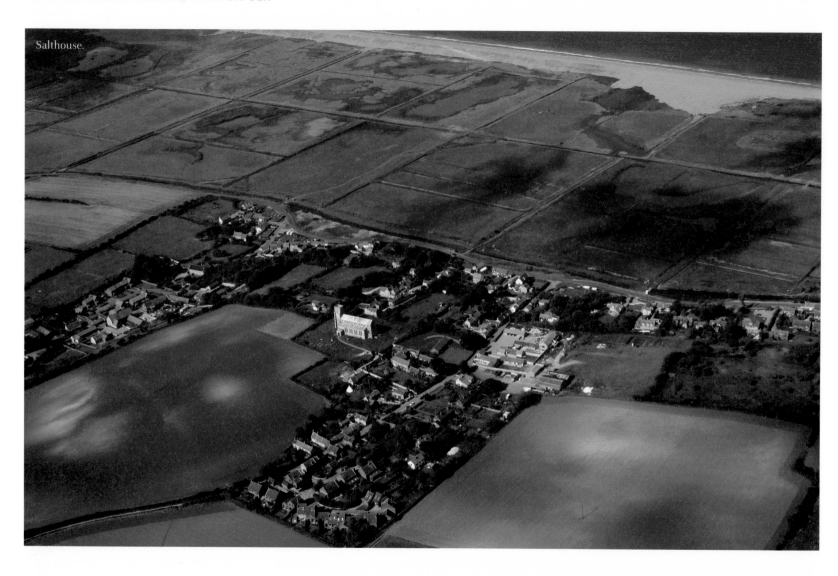

Salthouse.

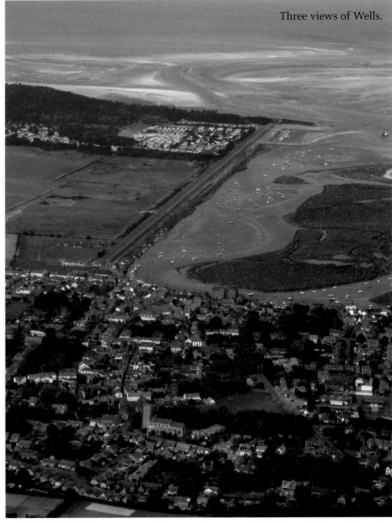

Three views of Wells.

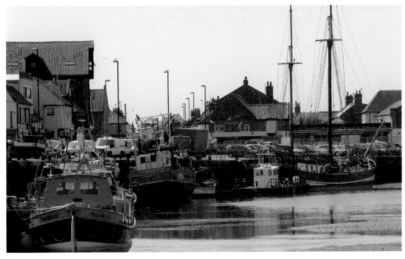

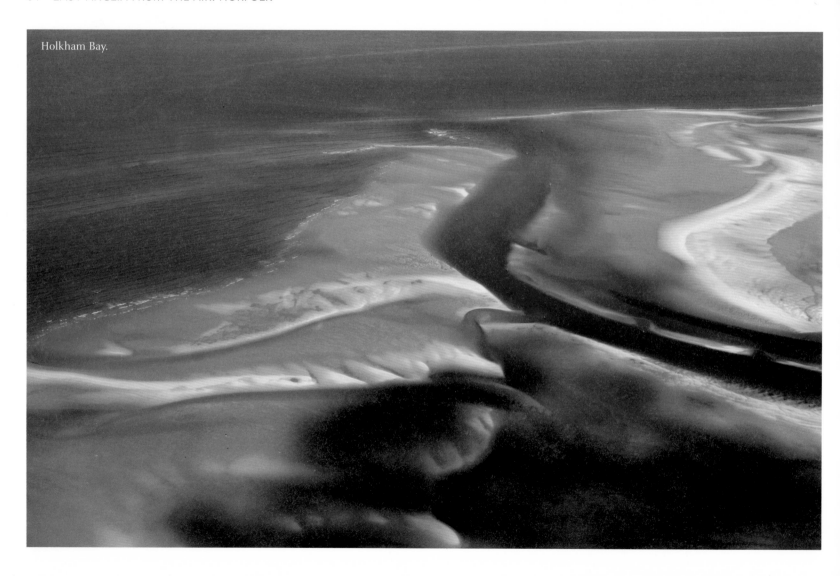

Holkham Bay.

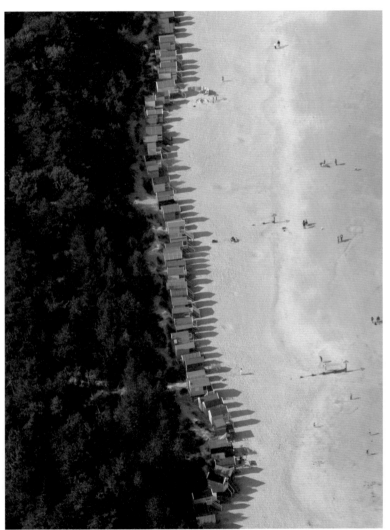

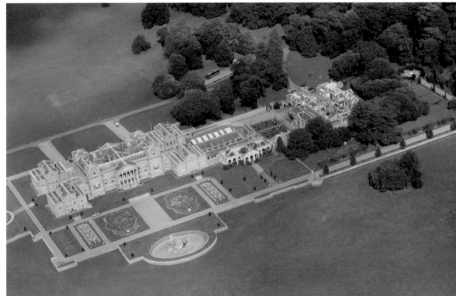

Beach huts at Wells (*left*) and Holkham Hall (*right*). The Hall is an eighteenth-century country house adjacent to the village of Holkham, constructed in the Palladian revival style for Thomas Coke, 1st Earl of Leicester. The Holkham estate had been purchased in 1609 by Sir Edward Coke, the founder of his family fortune. *Overleaf:* The Holkham Hall Estate is extensive (over 3,000 acres) and was landscaped by Capability Brown, who created the lake and planted thousands of trees. The Park reaches to Wells' western outskirts and the beach at Holkham Gap is reached down the half-mile Lady Ann's Drive, opposite the main gate of Holkham Hall.

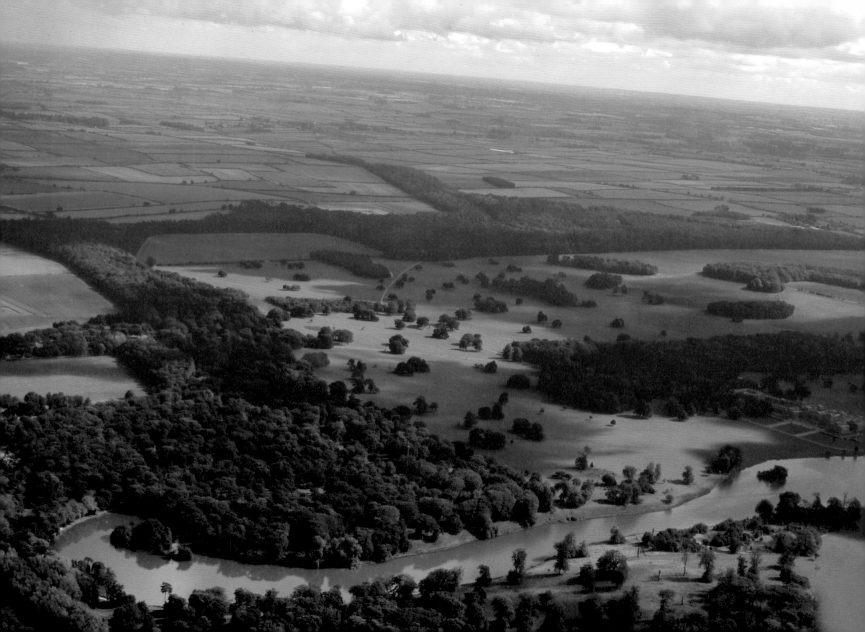

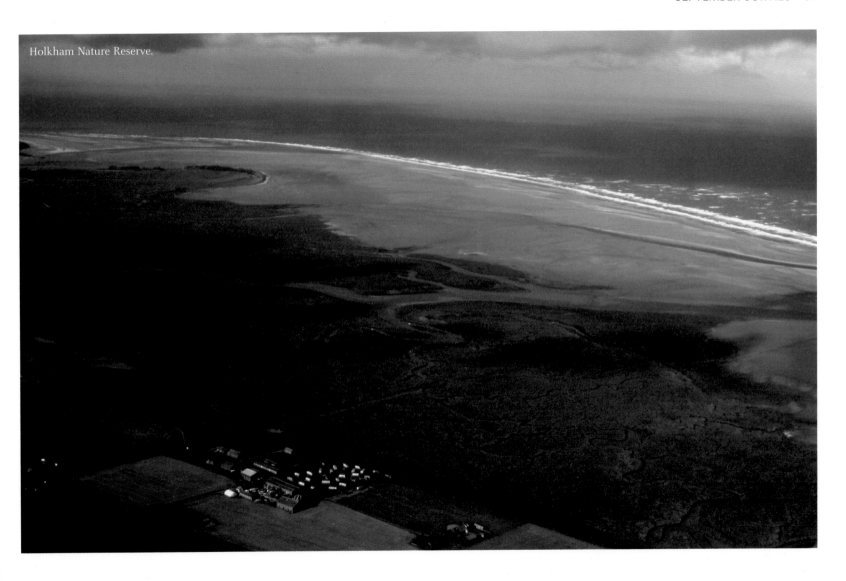

Holkham Nature Reserve.

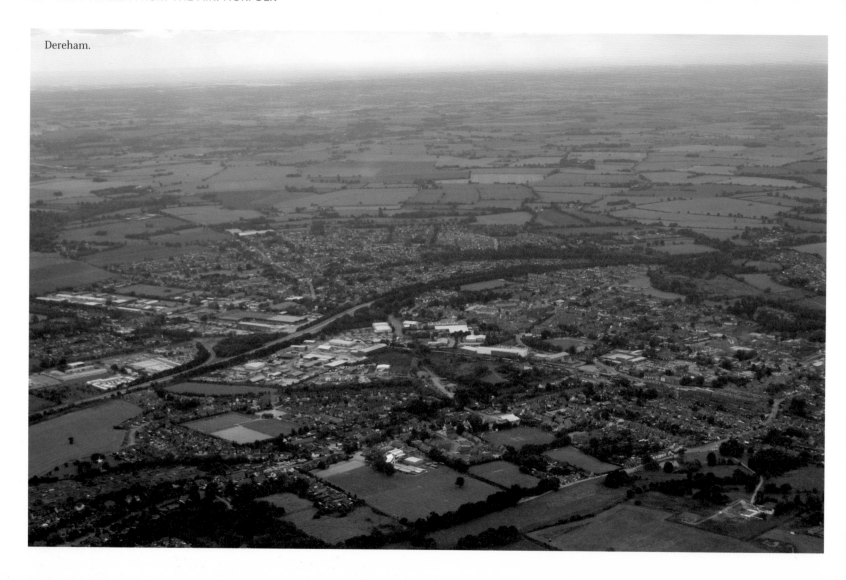

Dereham.

5

GOING DUTCH

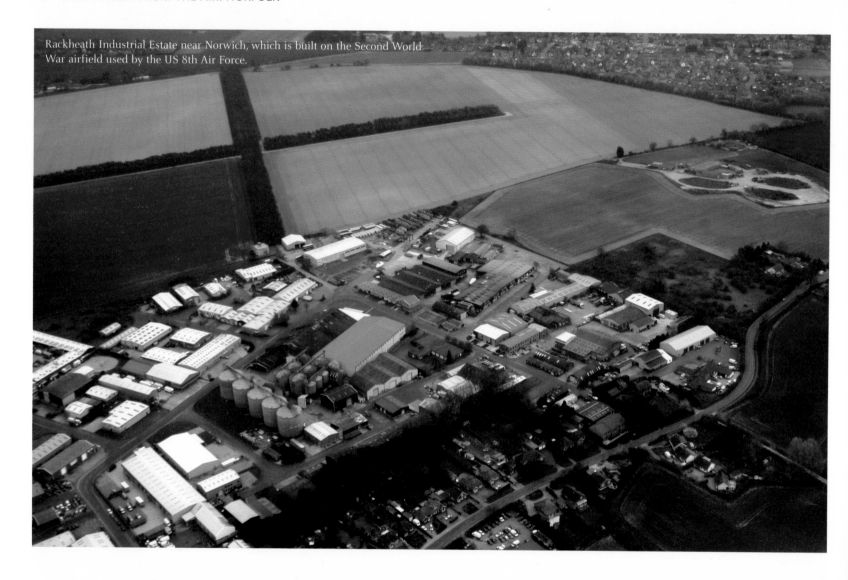

Rackheath Industrial Estate near Norwich, which is built on the Second World War airfield used by the US 8th Air Force.

'I'm Leaving on a Jet Plane' as Norfolk residents awake to another day.

Brundall Bay Marina, set in 50 acres of peaceful parkland, is the largest and best equipped marina on the Broads, with moorings for over 300 boats. There is a RSPB reserve beside the marina which is rich in wildlife.

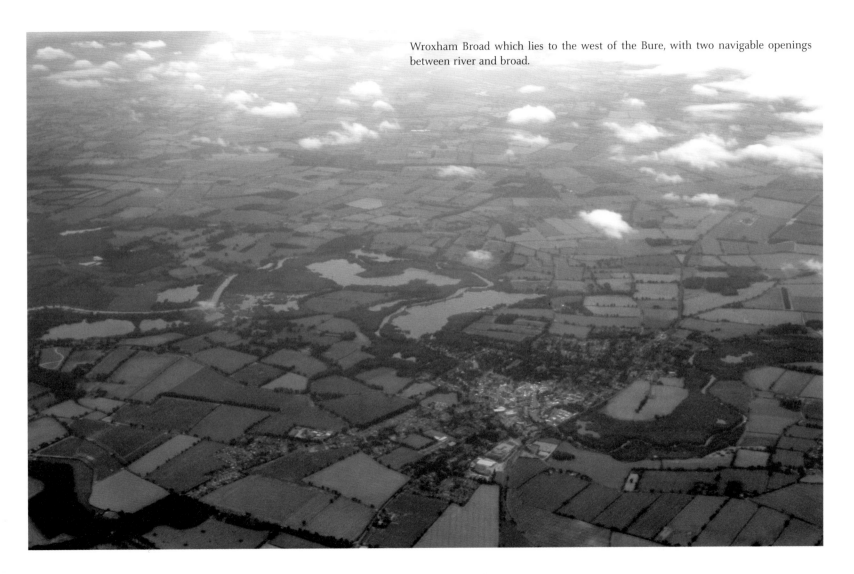

Wroxham Broad which lies to the west of the Bure, with two navigable openings between river and broad.

The Broads have been a boating holiday destination since the late nineteenth century.

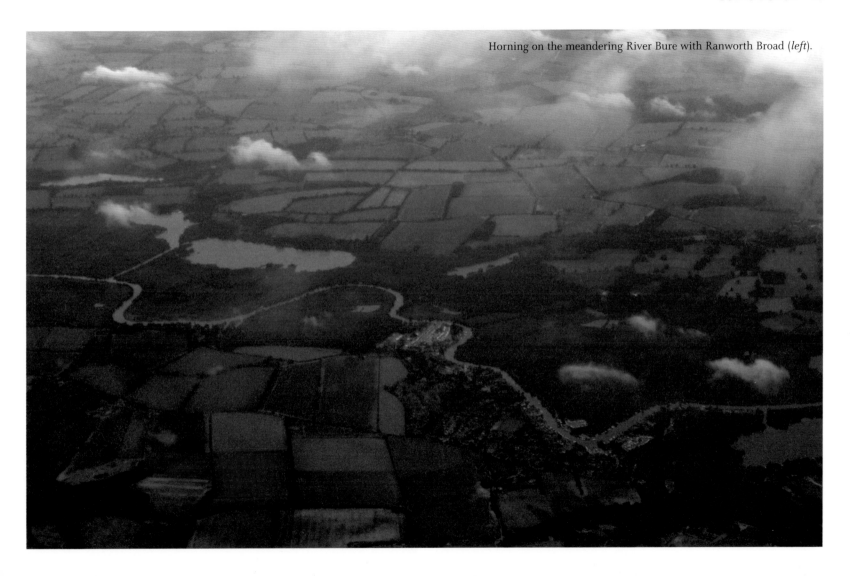

Horning on the meandering River Bure with Ranworth Broad (*left*).

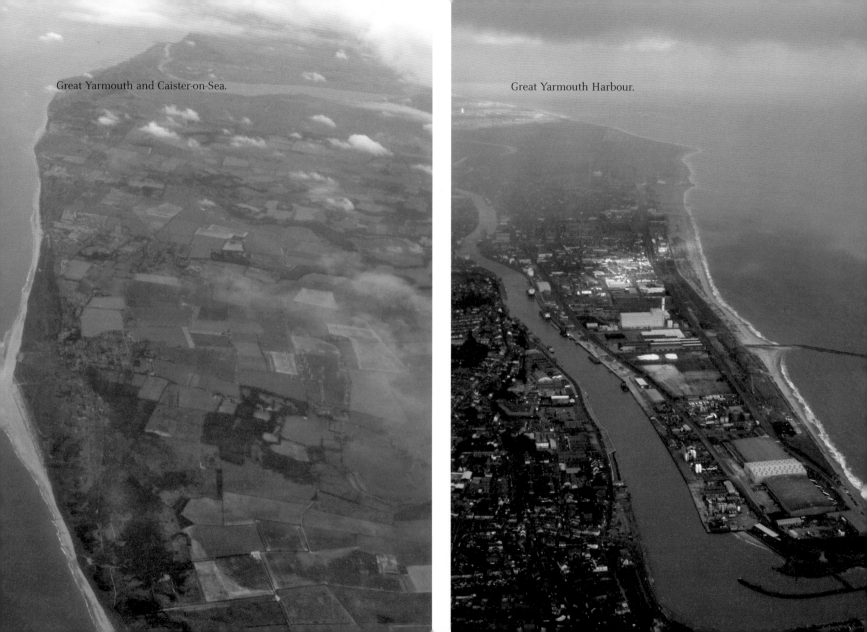

Great Yarmouth and Caister-on-Sea.

Great Yarmouth Harbour.

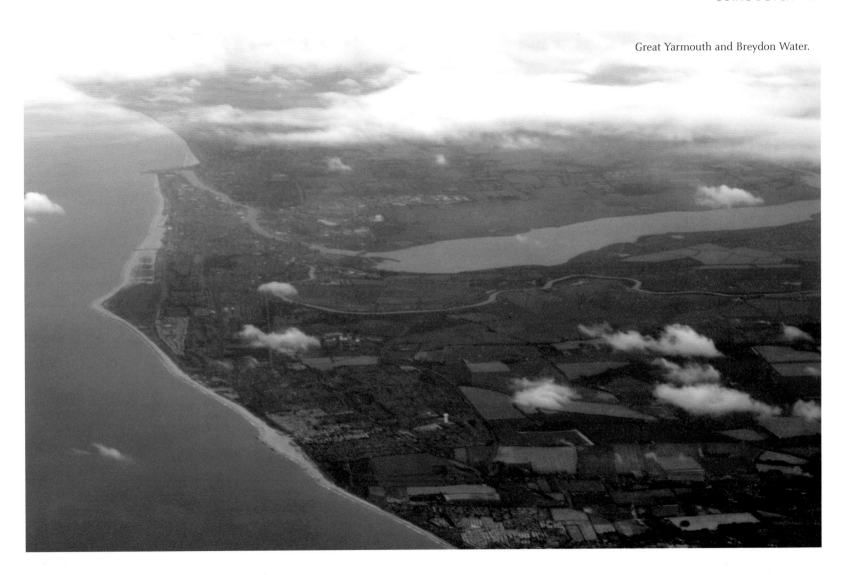

Great Yarmouth and Breydon Water.

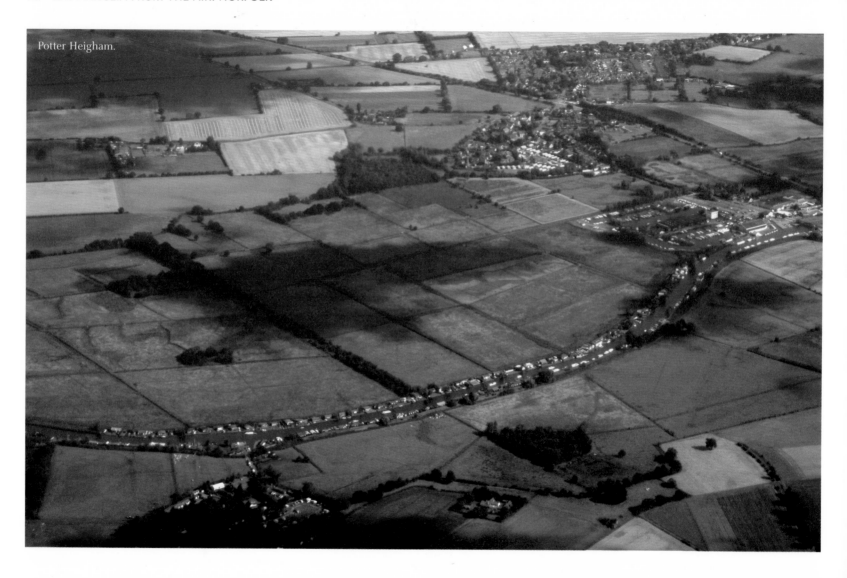

Potter Heigham.

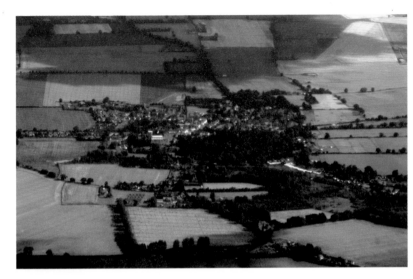

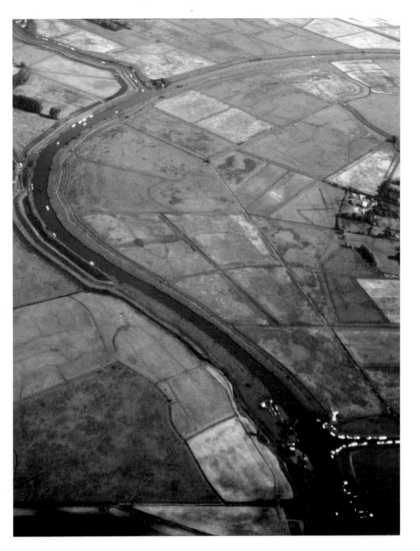

Above: Ludham.

Right: The Thurne and the Ant (*top left*). Thurne Mill (*bottom right*) was built *c.* 1820.

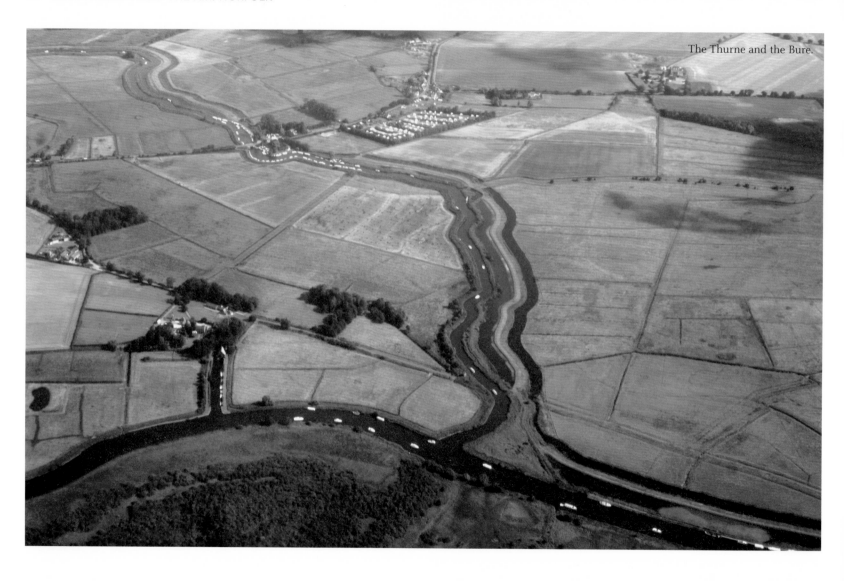

The Thurne and the Bure.

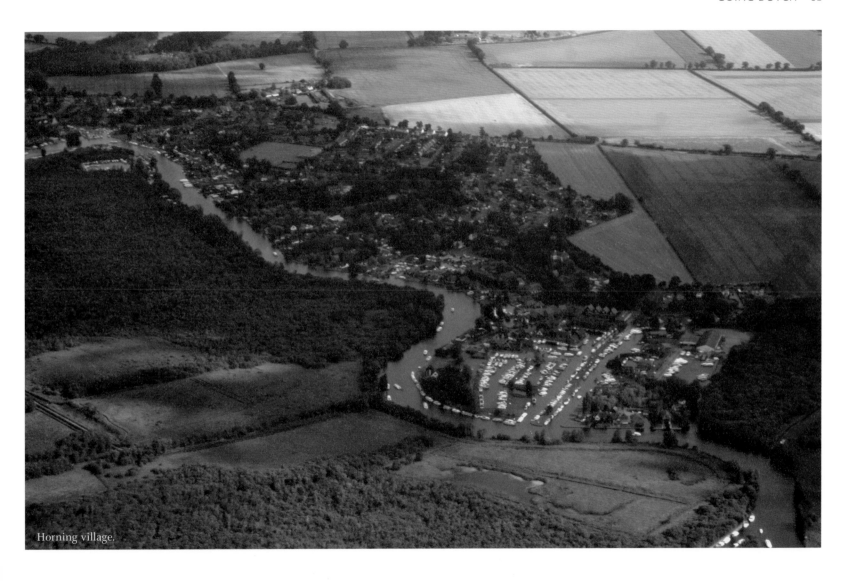

Horning village.

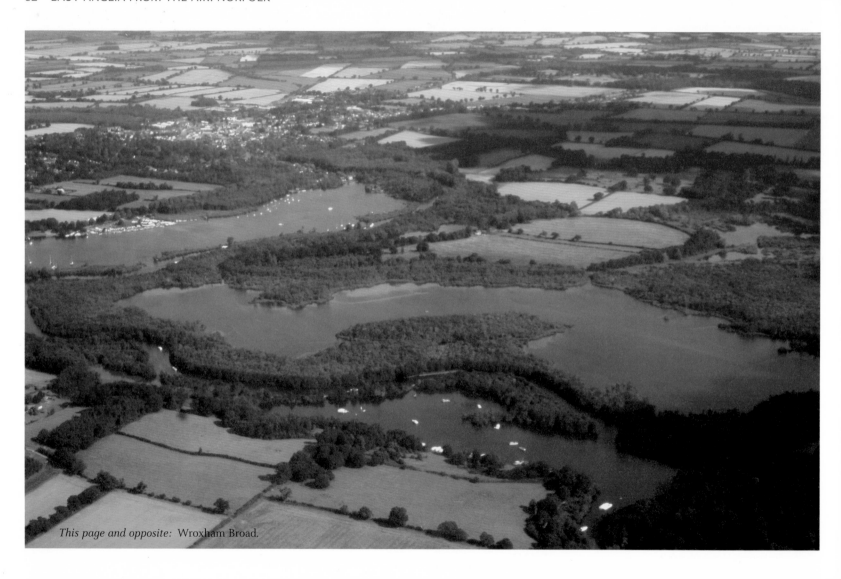

This page and opposite: Wroxham Broad.

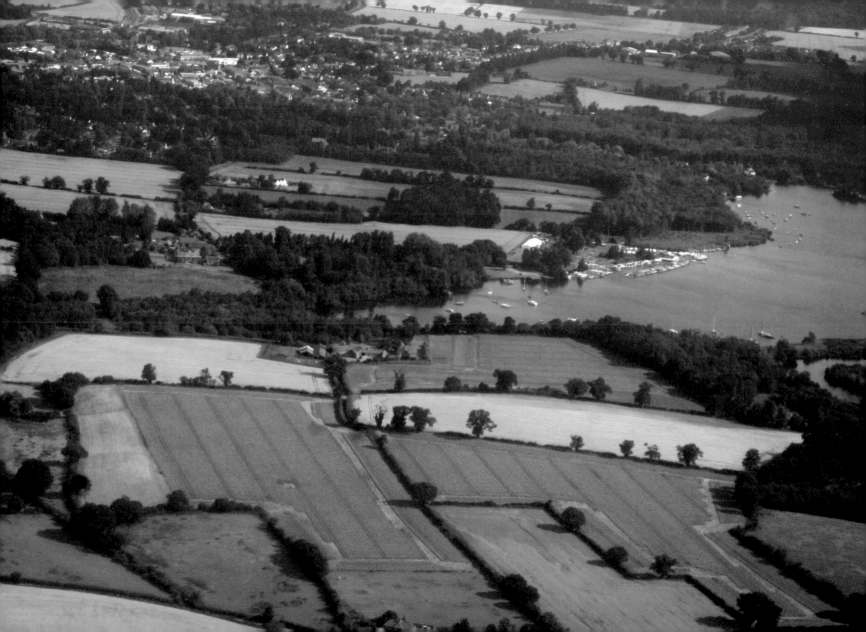

Great Yarmouth and Ormesby Broad. Rollesby, Ormesby, Filby and Lily Broads and Ormesby Little Broad which form Trinity Broads are connected to each other but they have no navigable connection to the rest of the broads.

6

REFLECTIONS OF NORWICH

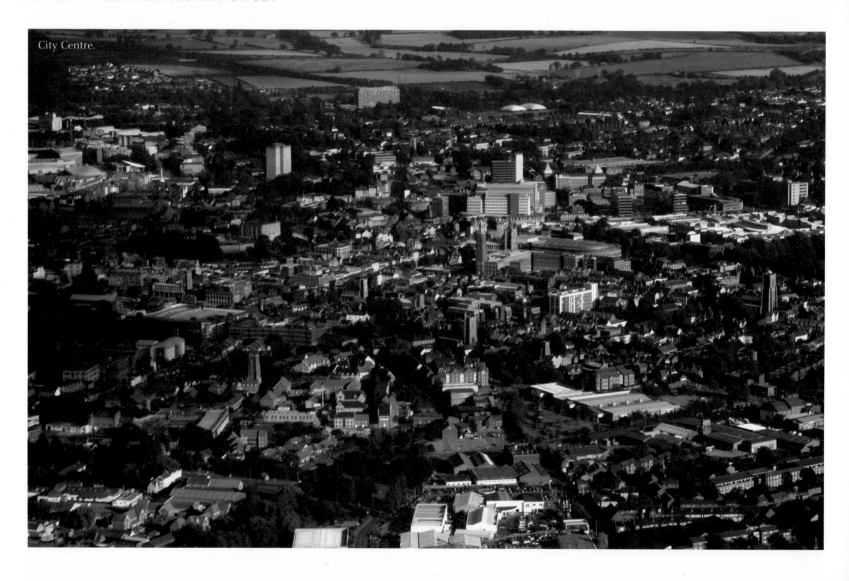

City Centre.

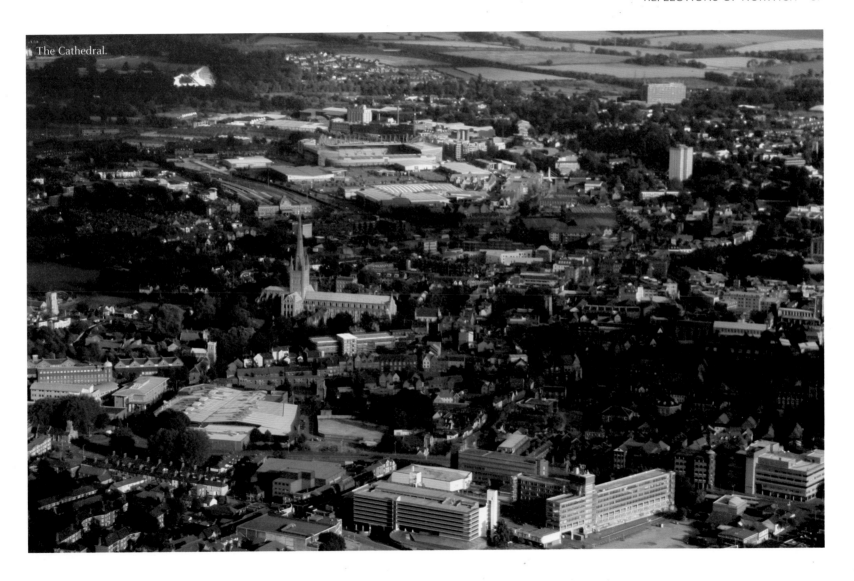

The Cathedral.

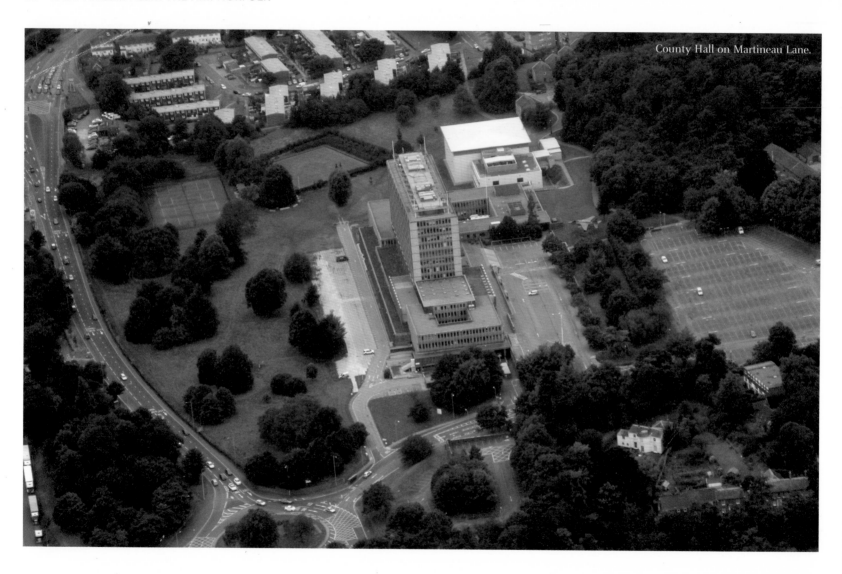

County Hall on Martineau Lane.

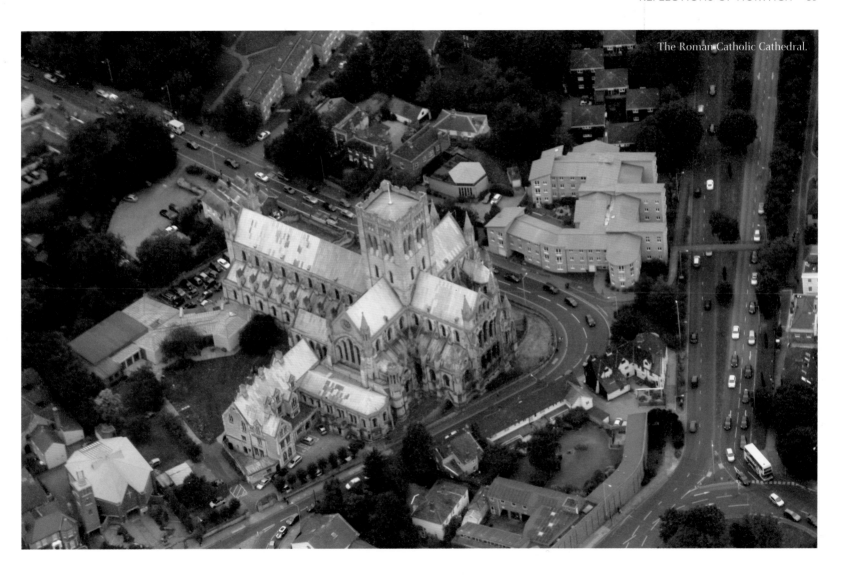

The Roman Catholic Cathedral.

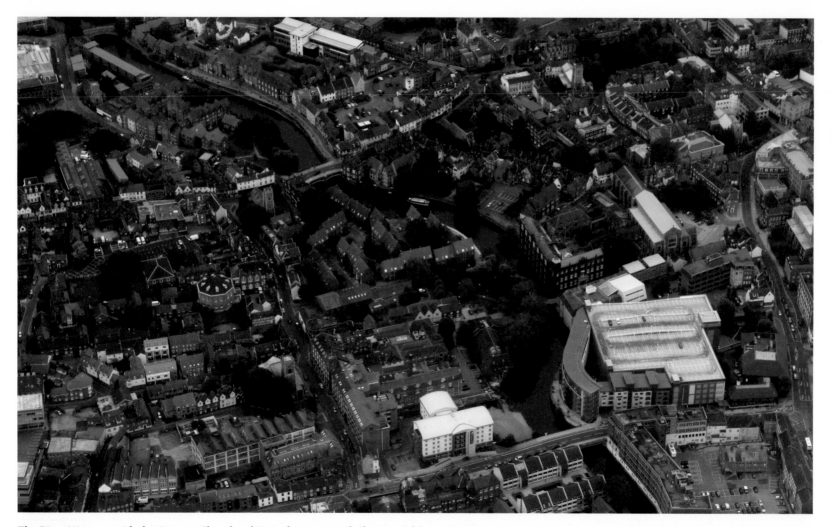

The River Wensum with the Octagon Chapel and St Andrews car park (*bottom right*).

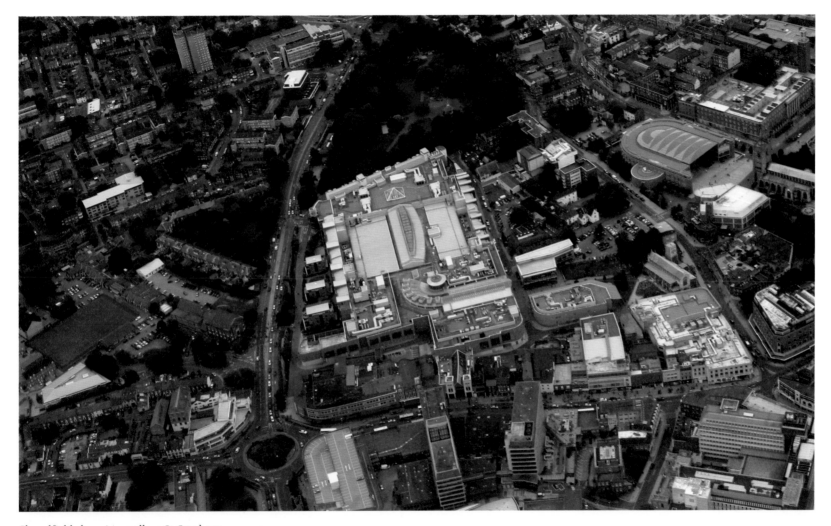

Chapelfield shopping mall on St Stephens.

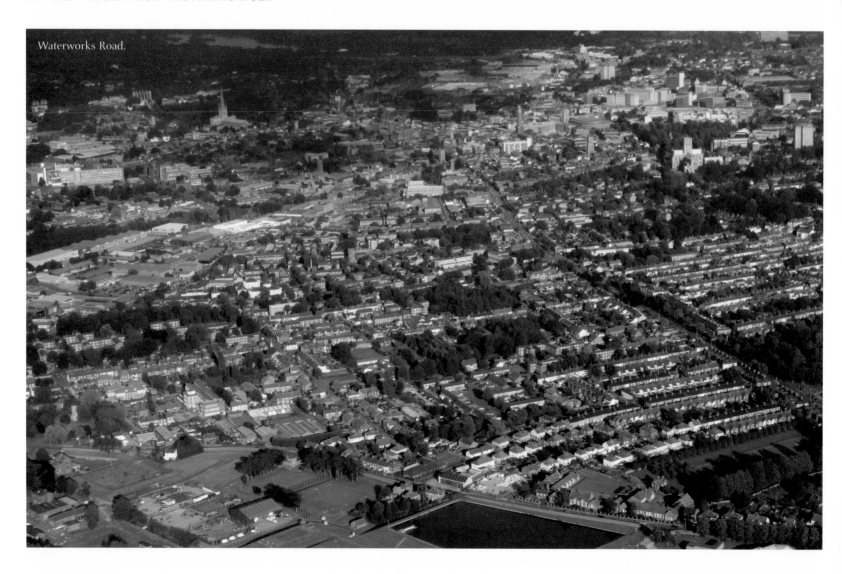

Waterworks Road.

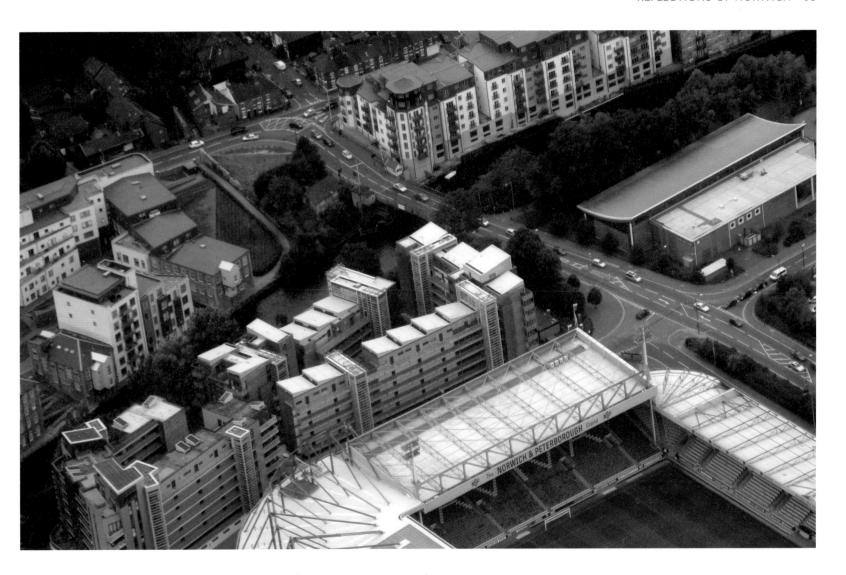

'On The Ball City!' NCFC play their home games at Carrow Road (*previous page and left*) and have done since 1935. The club was founded in 1902 and first won promotion to the Football League First Division in 1972. Since then the Canaries have played a total of twenty-three seasons in the top flight, with a longest continuous spell of nine seasons. Norwich has won the League Cup twice, in 1962 and 1985, and the FA Youth Cup twice, in 1983 and 2013. They were founder members of the Premier League in 1992–93, finishing third in the inaugural season, and played in its first three seasons, reaching the UEFA Cup third round. Norwich most recently returned to the Premier League in 2011 after a six-year absence.

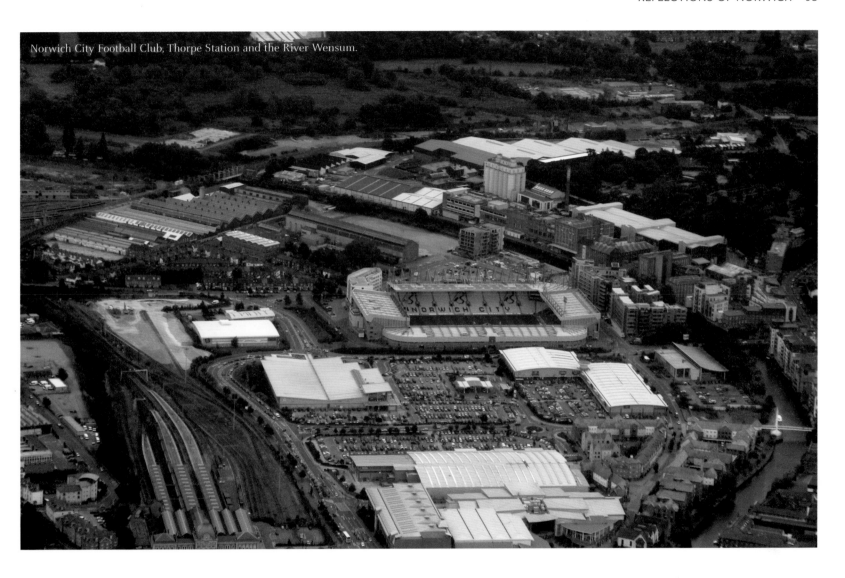

Norwich City Football Club, Thorpe Station and the River Wensum.

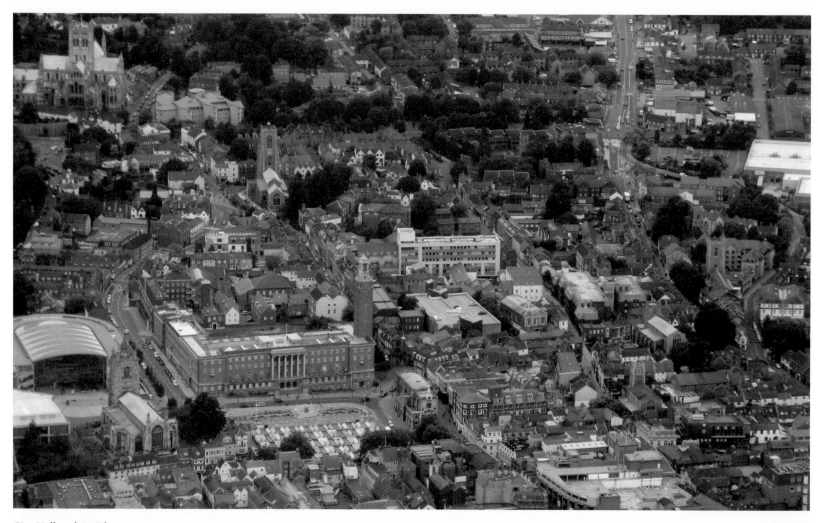

City Hall and St Giles.

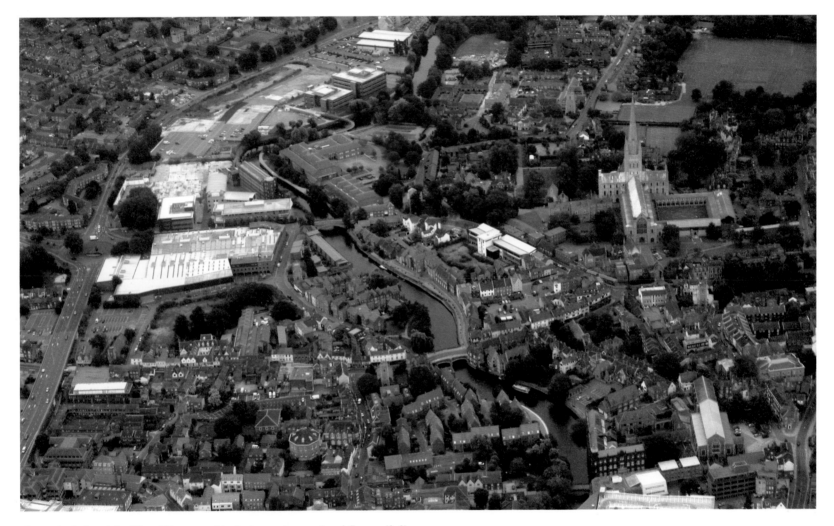

The Cathedral and the River Wensum with the inner ring road and flyover (*left*).

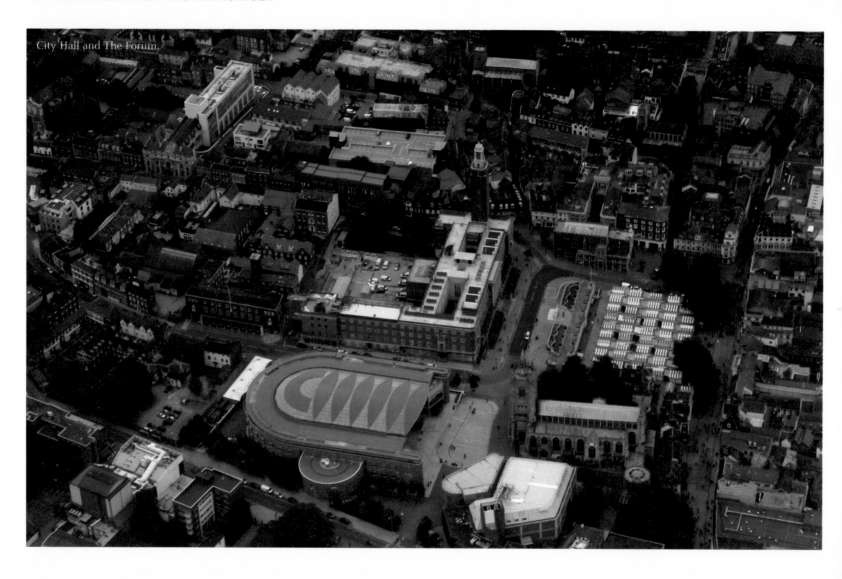

City Hall and The Forum.

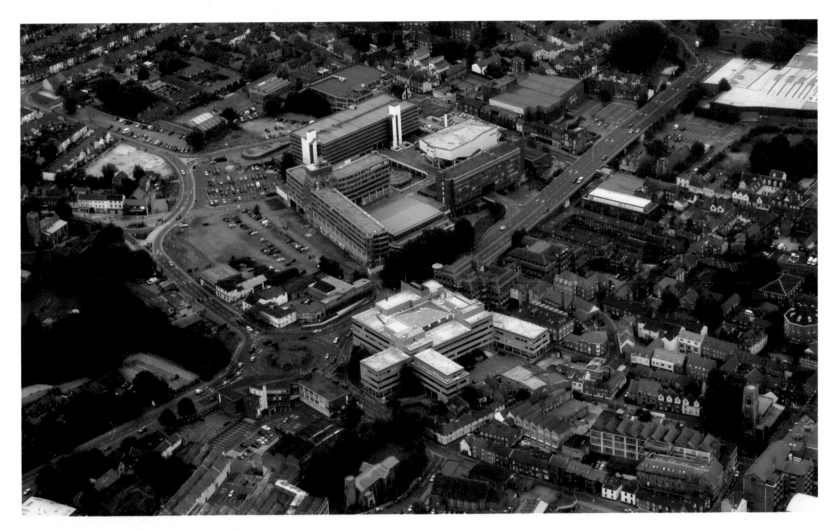

St Crispins, HMSO, Anglia Square and the flyover.

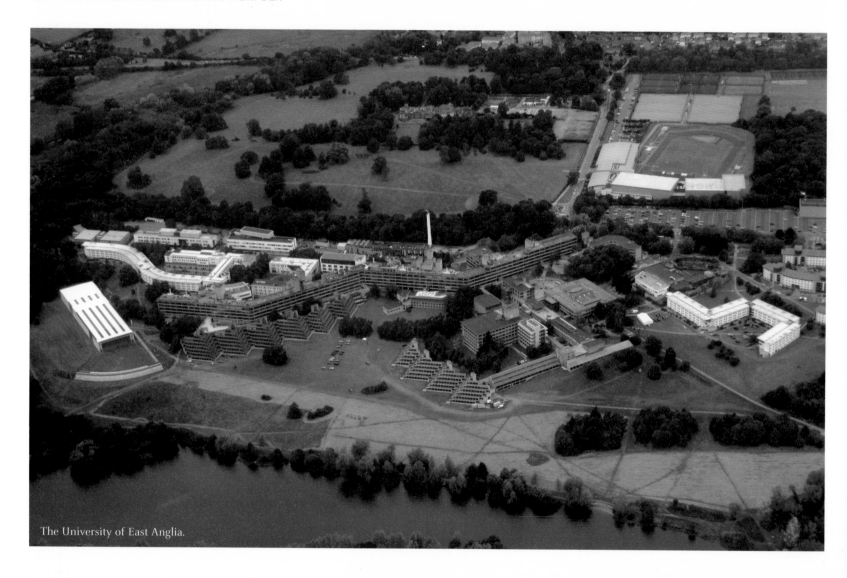

The University of East Anglia.

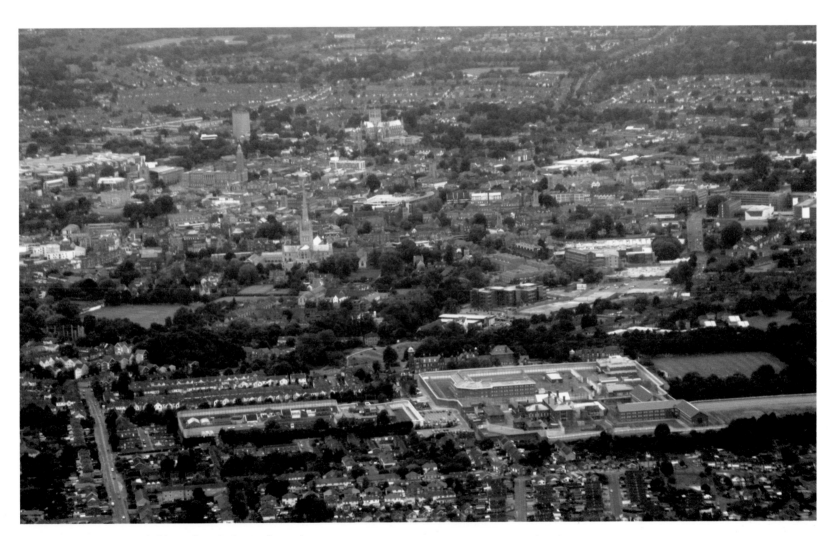

Norwich Prison on Mousehold Heath with the city beyond.

Thorpe Station and the Post Office Sorting Office.

This page: London Street, Dipples on Swan Lane and the market.

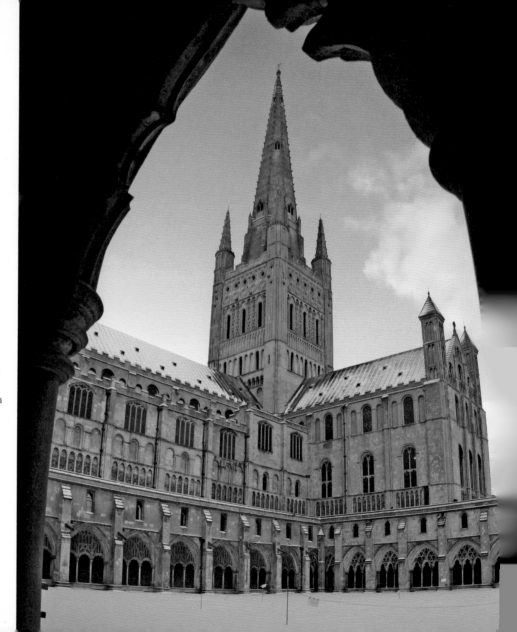

Norwich Cathedral in the winter snow. In 1096, Herbert de Losinga, the Bishop of Thetford, began construction of the Cathedral, the chief building material for which was limestone imported from Caen in Normandy. To transport the building stone to the cathedral site, a canal was cut from the river (from the site of present-day Pulls Ferry), all the way up to the east wall. Norwich Castle was founded soon after the Norman Conquest. Norwich is the regional administrative centre and county town of Norfolk. During the eleventh century, Norwich was the largest city in England after London. Until the Industrial Revolution, Norwich was the capital of the most populous county in England and vied with Bristol as England's second city. Over 132,500 people live in the city and the population of the Norwich Travel to Work Area in which most people live and commute to work is 282,000. In May 2012 Norwich was designated as England's first UNESCO City of Literature.

7

LOST SORTIE TO SANDRINGHAM

The Fens shrouded in mist.

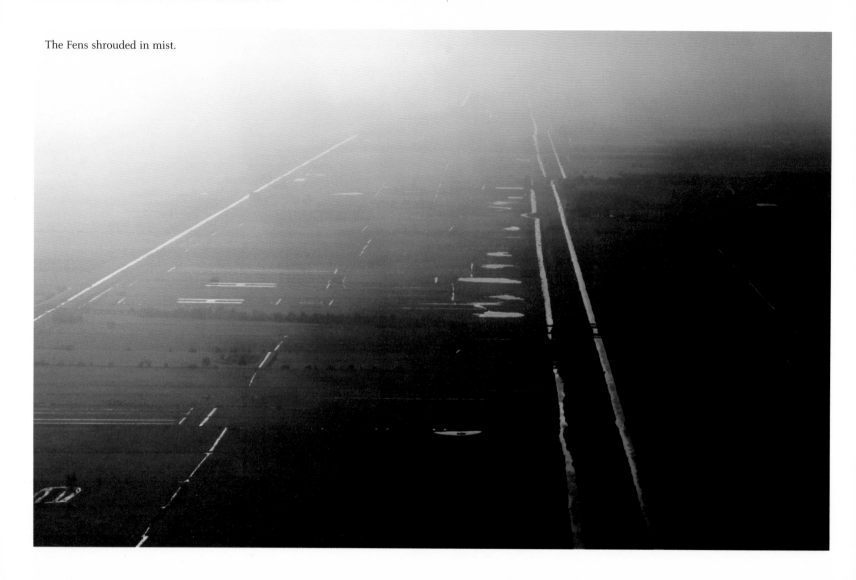

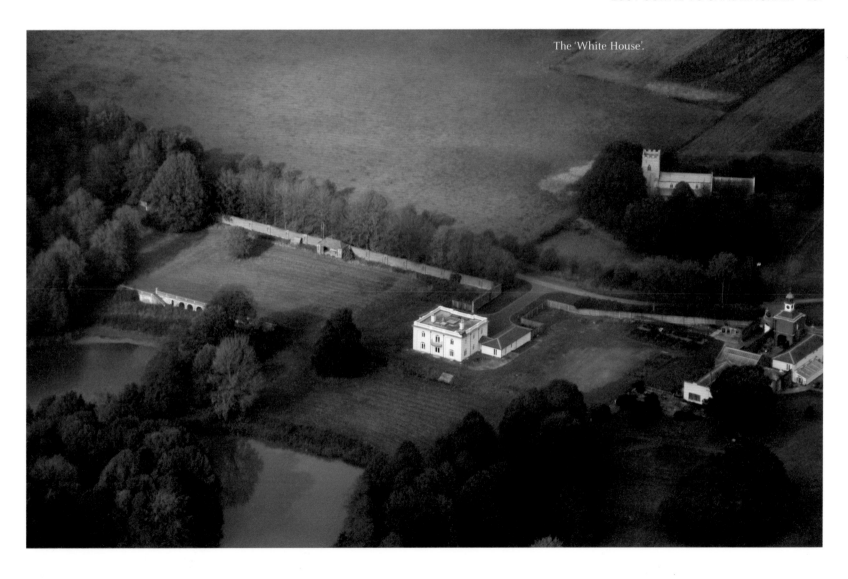

The 'White House'.

Wayland Prison in the parish of Griston near Watton. During the Second World War it was the site of a USAAF base.

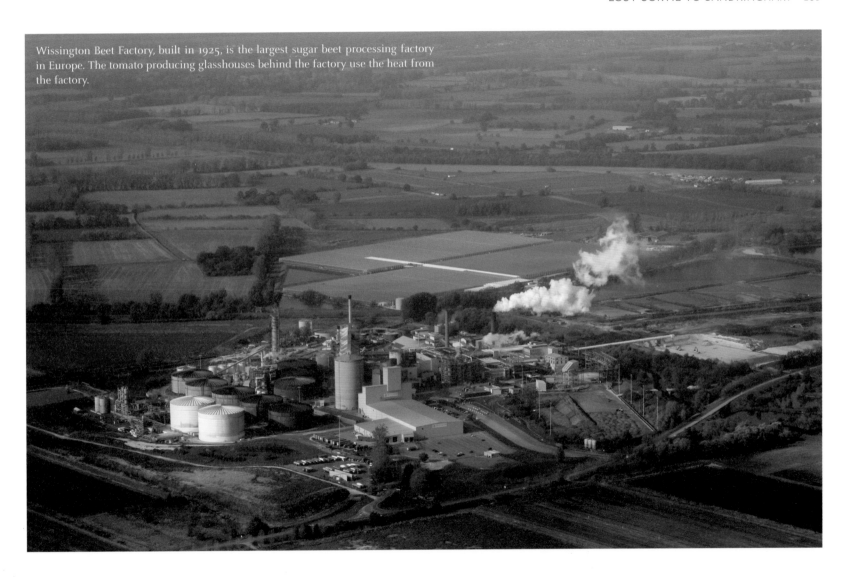

Wissington Beet Factory, built in 1925, is the largest sugar beet processing factory in Europe. The tomato producing glasshouses behind the factory use the heat from the factory.

Fenland canal near King's Lynn.

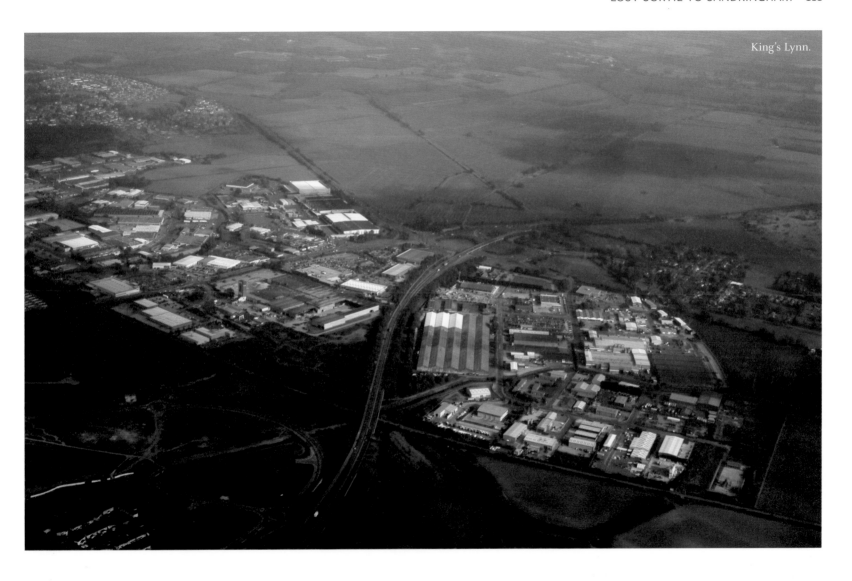

King's Lynn.

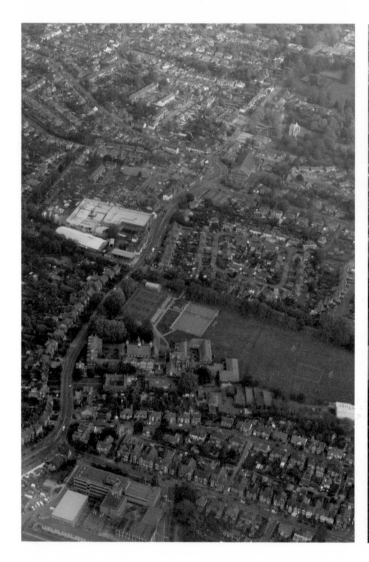

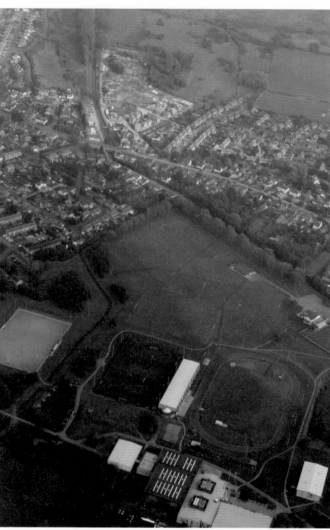

This page: King's Lynn.

Beware glider!

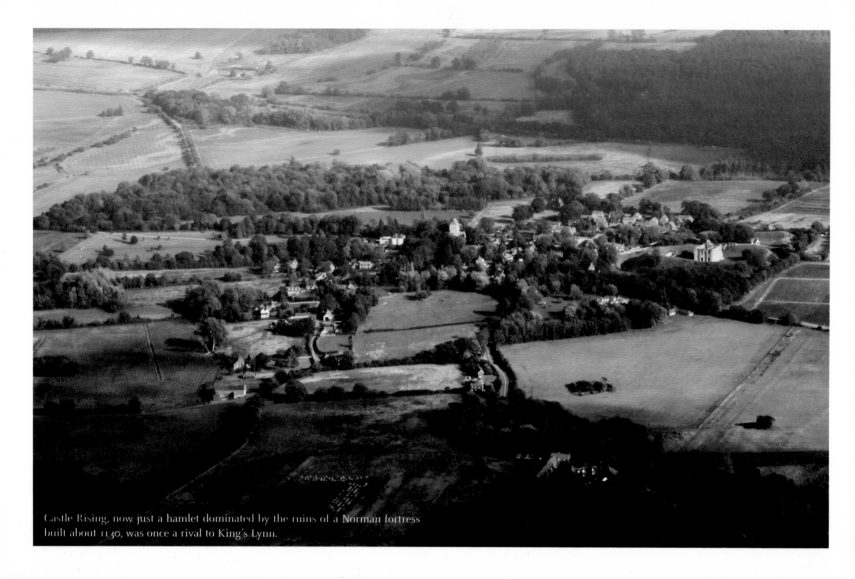

Castle Rising, now just a hamlet dominated by the ruins of a Norman fortress built about 1130, was once a rival to King's Lynn.

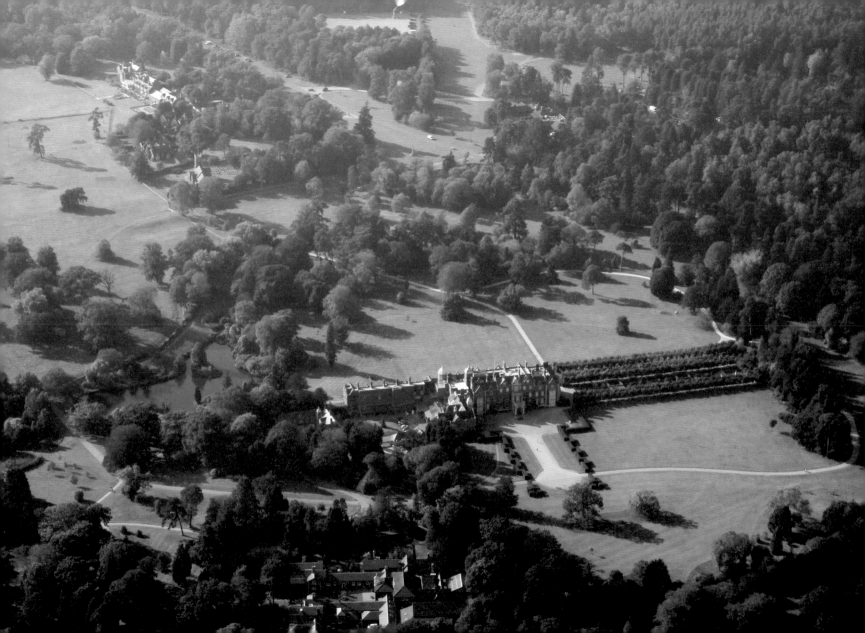

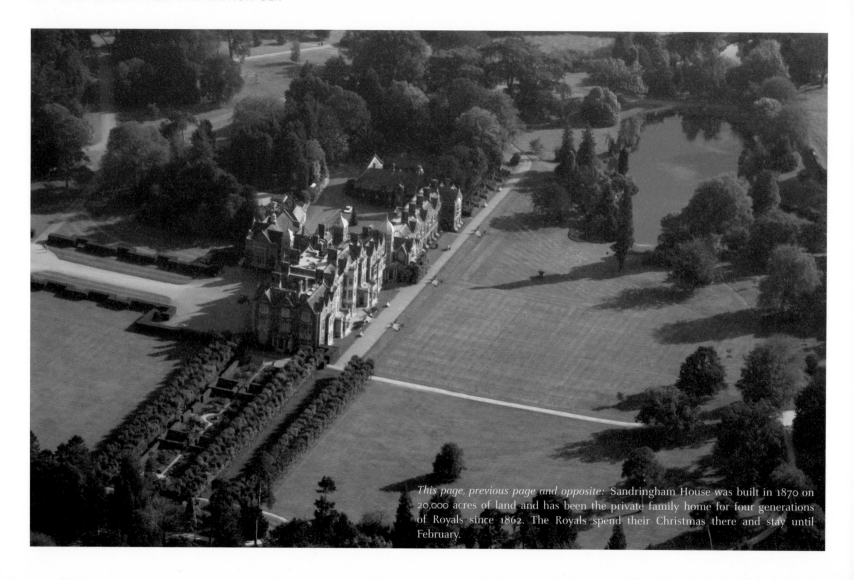

This page, previous page and opposite: Sandringham House was built in 1870 on 20,000 acres of land and has been the private family home for four generations of Royals since 1862. The Royals spend their Christmas there and stay until February.

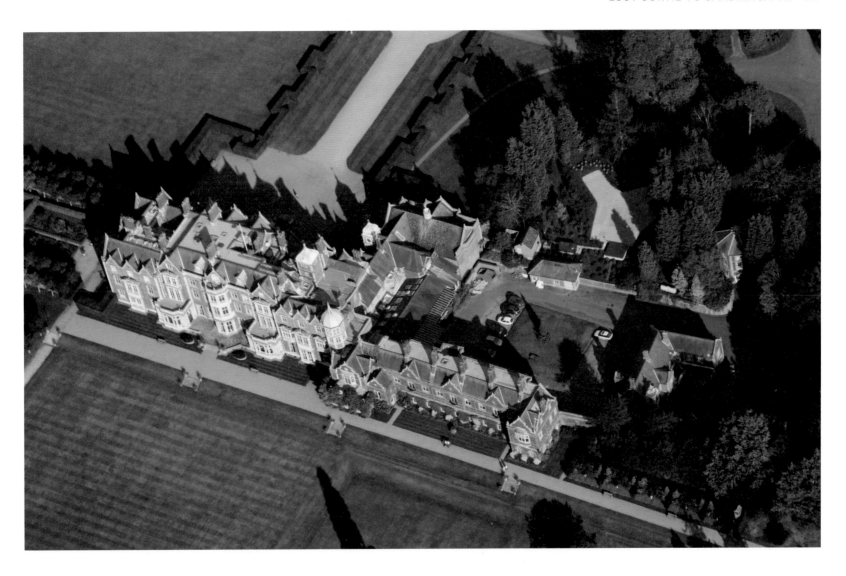

The Wash.

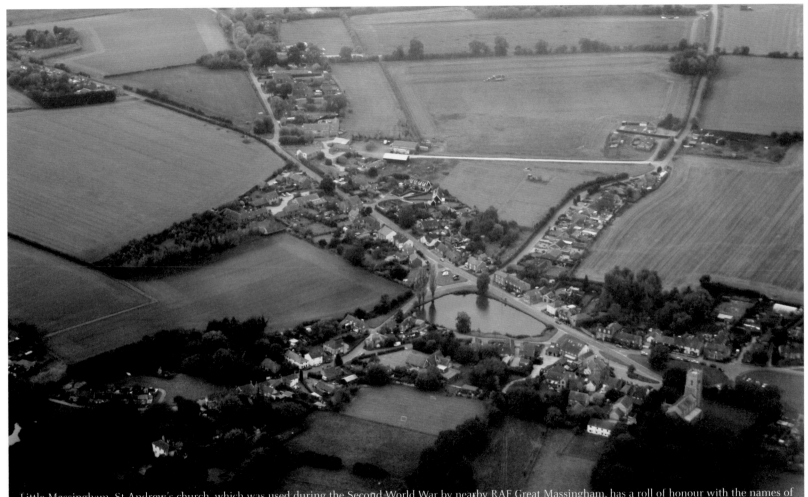

Little Massingham. St Andrew's church, which was used during the Second World War by nearby RAF Great Massingham, has a roll of honour with the names of those who served at the airfield and the church yard contains graves of some of the aircrew.

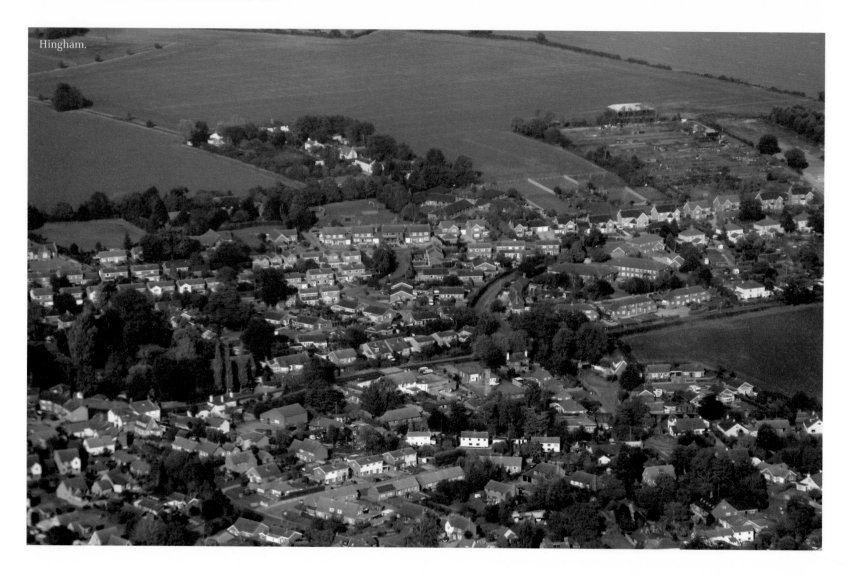

Hingham.

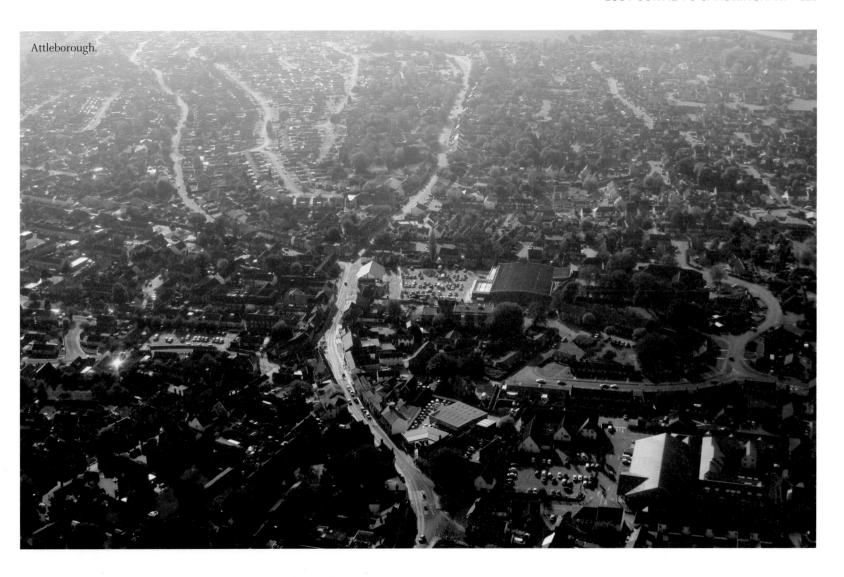

Attleborough.

8

SPRINGWATCH SORTIE

Porsche 917K.

Snetterton Sunday Market.

The race track originally started as an RAF airfield which was then designated for use by the USAAF and was opened in May 1943 and closed in November 1948. In the 1960s and early 1970s the circuit was 2.7 miles in length.

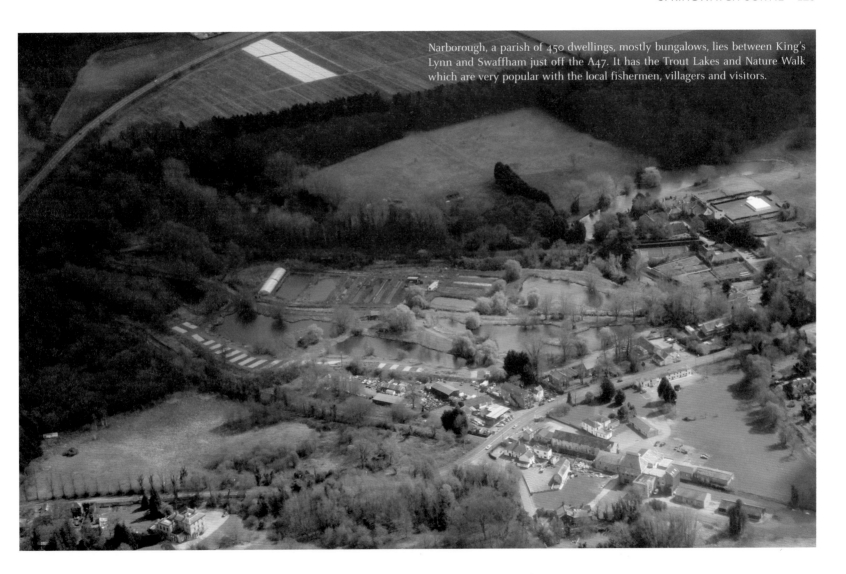

Narborough, a parish of 450 dwellings, mostly bungalows, lies between King's Lynn and Swaffham just off the A47. It has the Trout Lakes and Nature Walk which are very popular with the local fishermen, villagers and visitors.

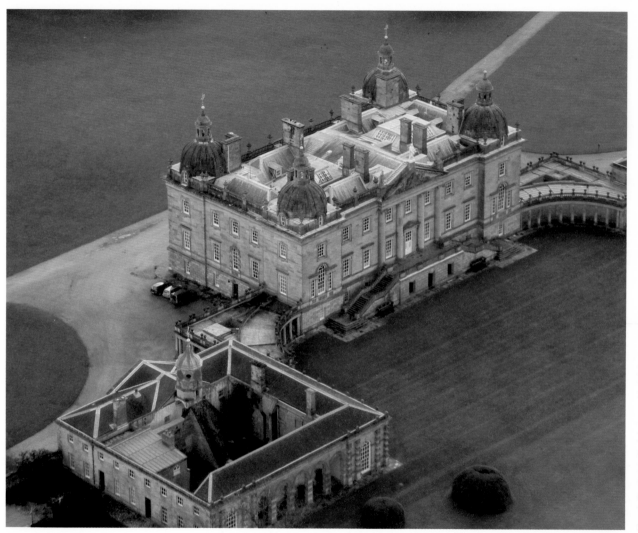

Houghton Hall is the home of David Cholmondeley, 7th Marquess of Cholmondeley. This Grade I listed building, surrounded by 1,000 acres of parkland adjacent to Sandringham House, was built for the first British Prime Minister, Sir Robert Walpole, and it is a key building in the history of Palladian architecture in England.

Opposite: RAF Marham, which is home to the frontline squadrons of the RAF's Tornado GR4 Force. In 2013 it was announced that the base will be the future home of the F-35 Lightning Force, the UK's first ever 5th Generation, multi-role, stealth fighter.

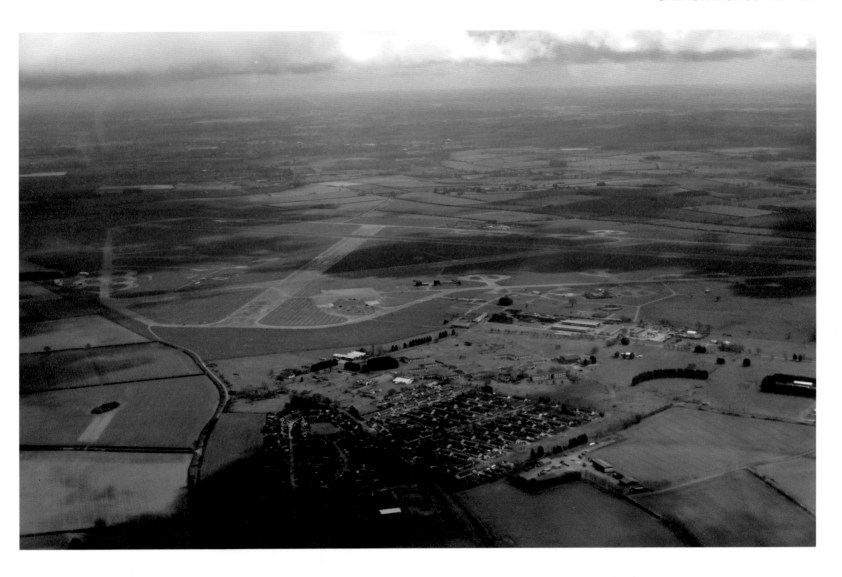

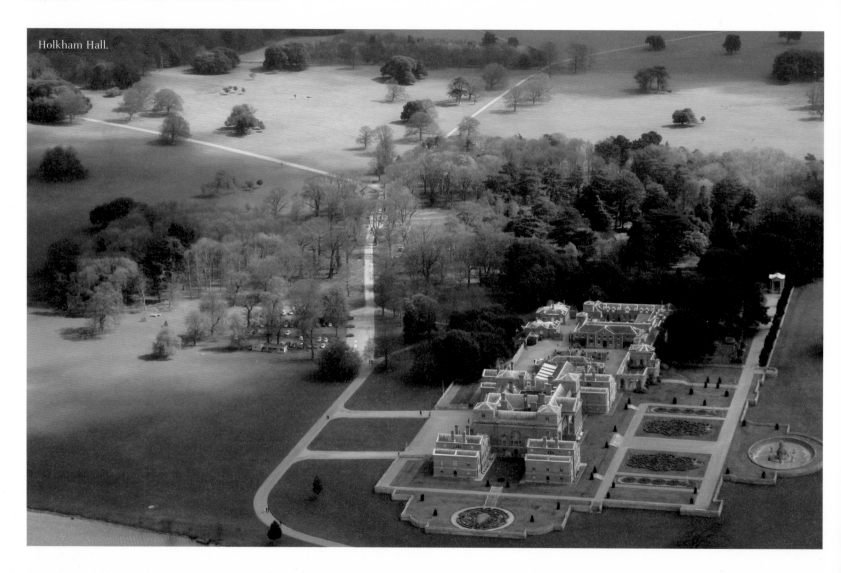

Holkham Hall.

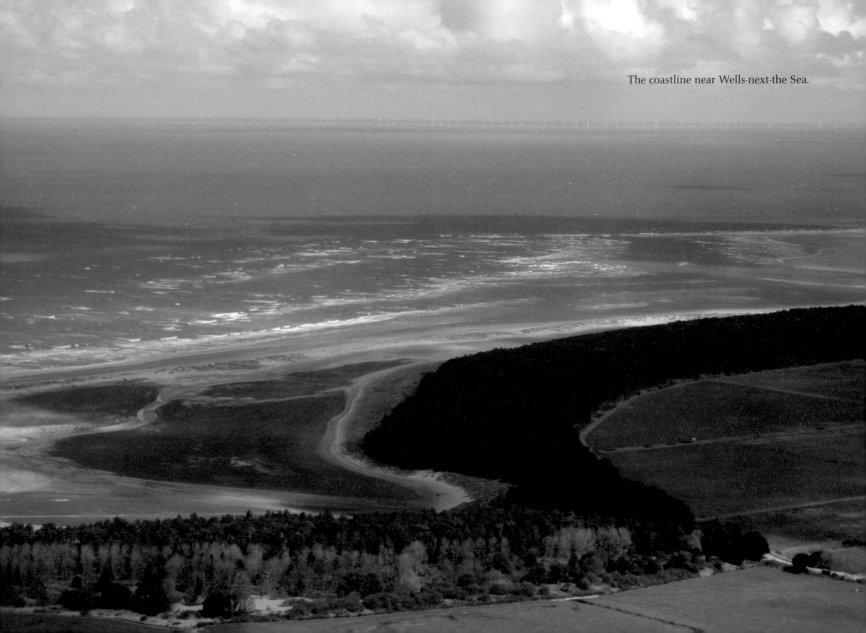

The coastline near Wells-next-the Sea.

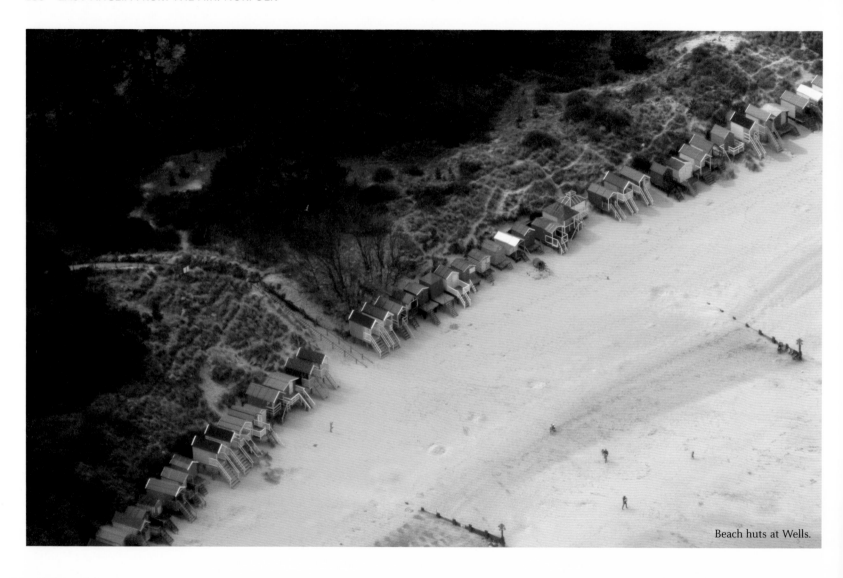

Beach huts at Wells.

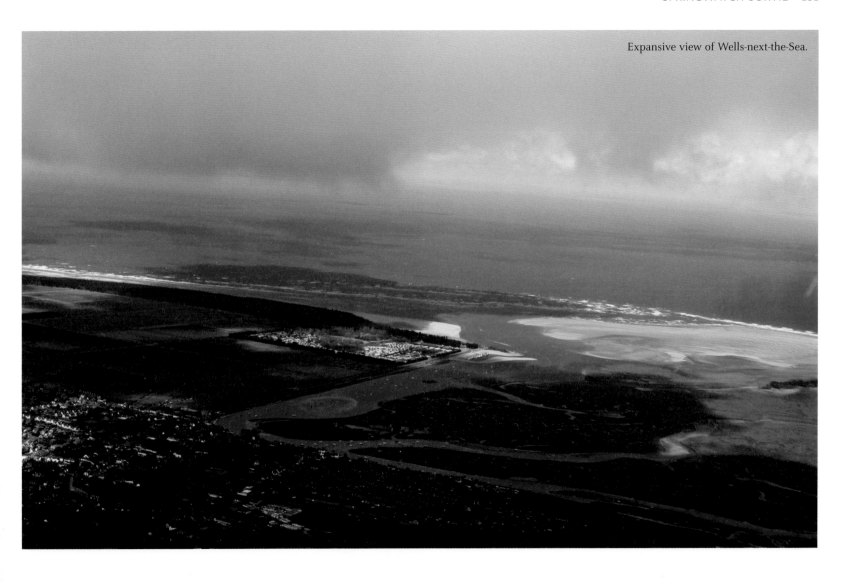

Expansive view of Wells-next-the-Sea.

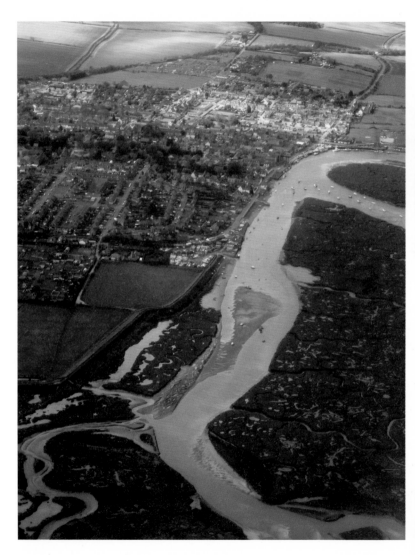

Wells at low tide (*left*) and Holkham Beach. At Wells the main channel belonging to the Holkham Estate was drained and embanked in the nineteenth century, in contrast to the salt marshes at East Hills which remain undisturbed (*next page*).

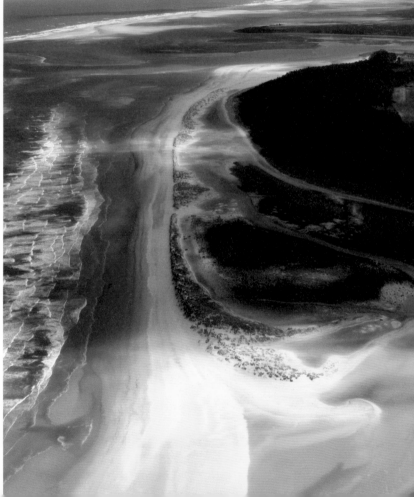

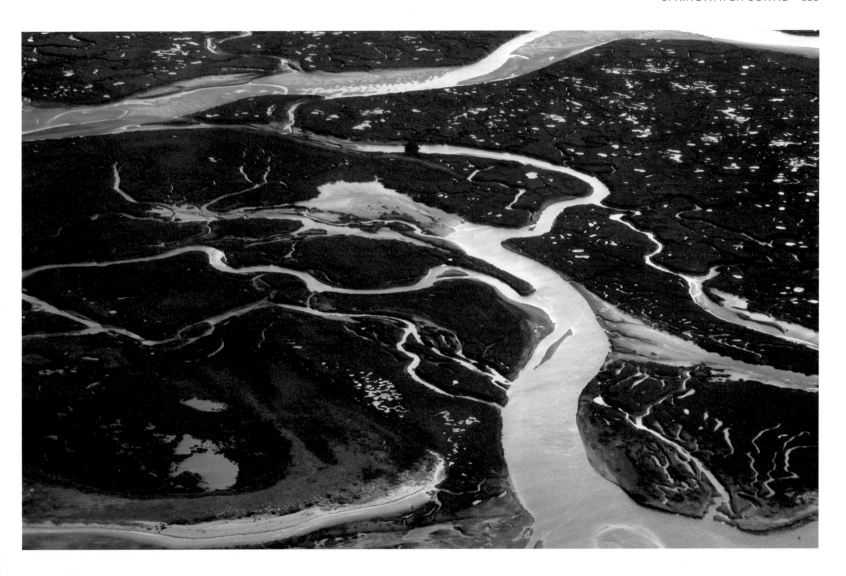

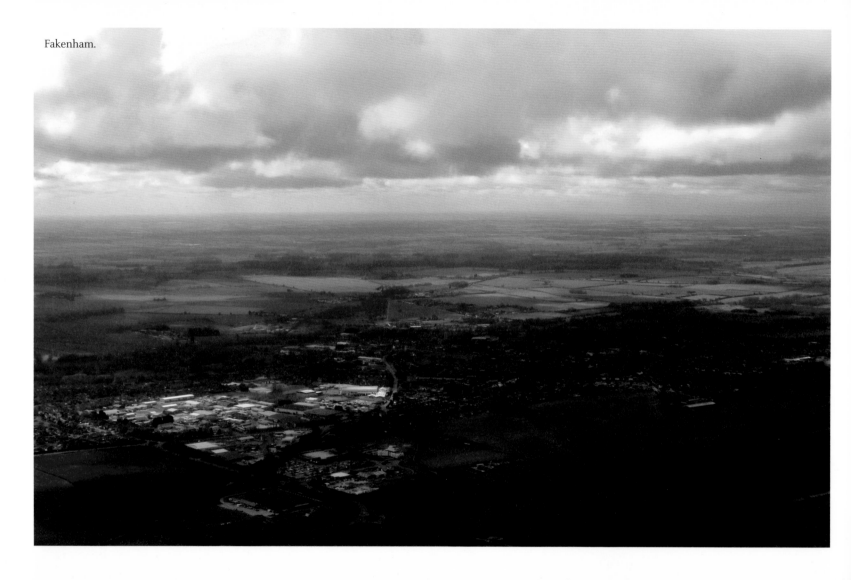

Fakenham.

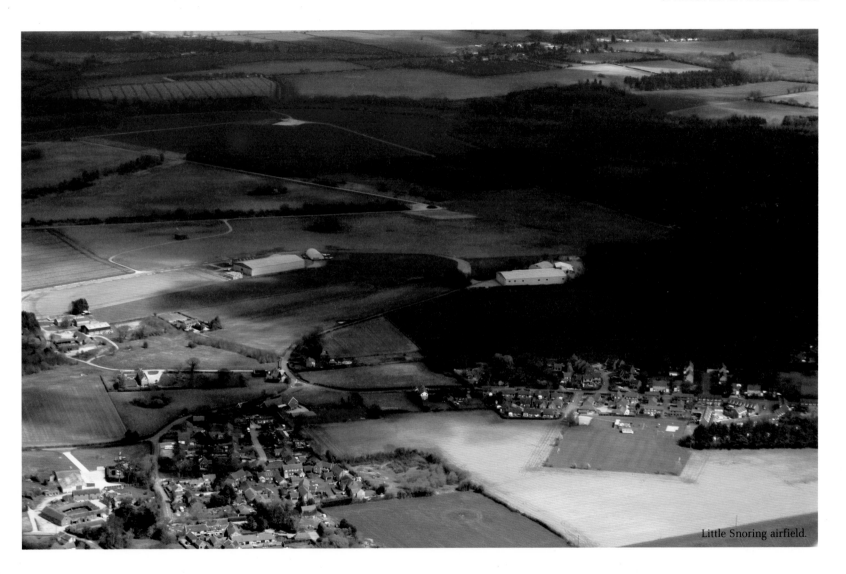

Little Snoring airfield.

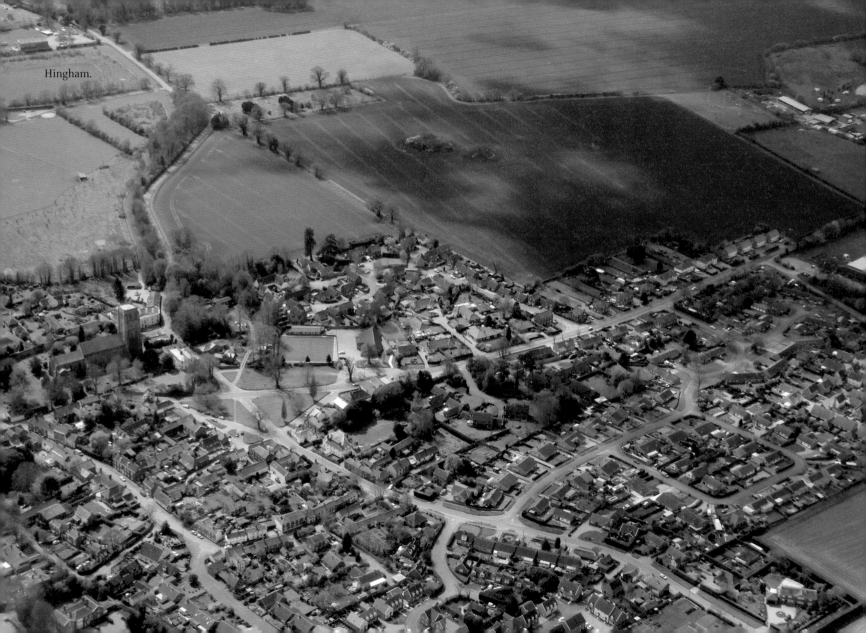

Hingham.

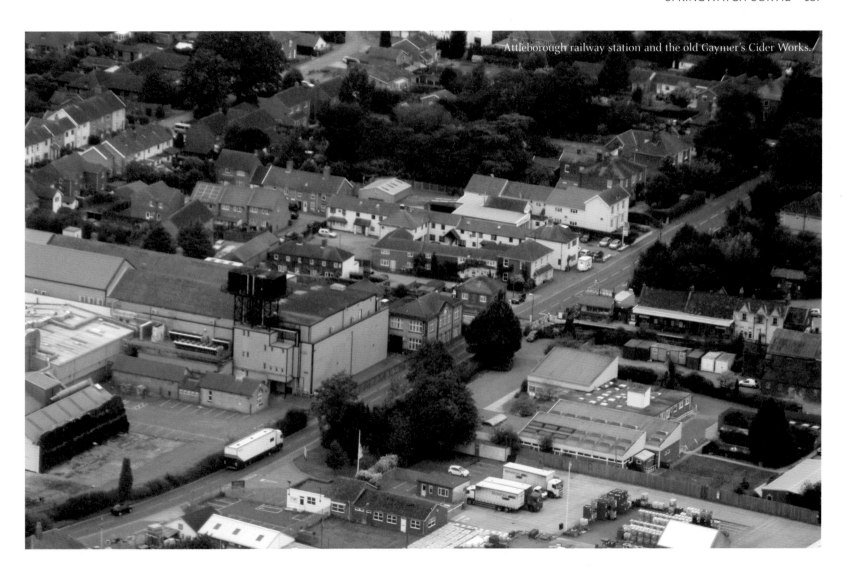

Attleborough railway station and the old Gaymer's Cider Works.

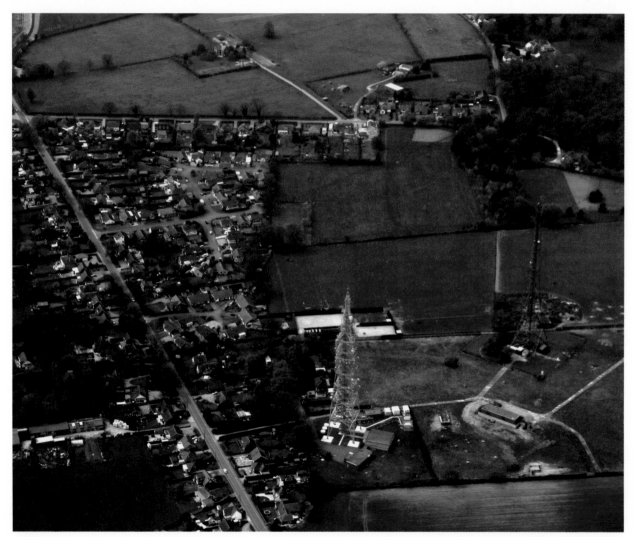

At Poringland, approximately 4 miles south of Norwich, there are two tall radio towers to the east of the village, mostly in the parish of Caistor St Edmund. One is one of three former Chain Home radar towers from the Battle of Britain when it was called RAF Stoke Holy Cross and it is still owned by the MoD. A larger 'stepped' tower owned by BT sits nearby.

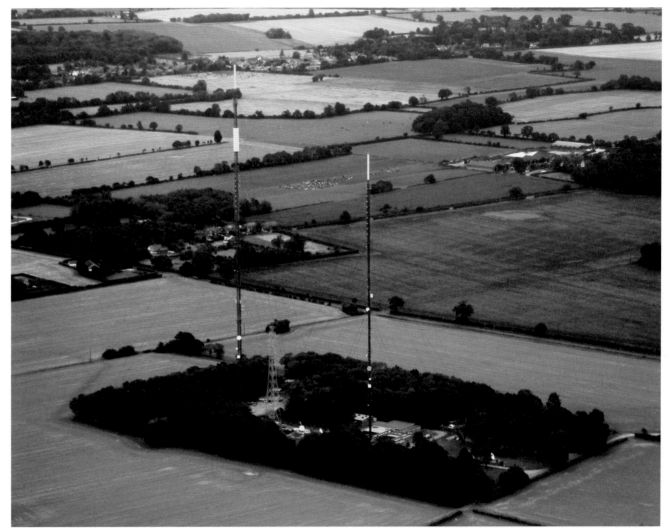

Tacolneston, approximately ten miles south-west of Norwich is the main station for UHF and BBC FM radio across Norfolk. The station came into operation in early 1955, initially broadcasting BBC 405-line television on VHF Band I. BBC National FM Radio has been provided from here since 1957 and UHF television since 1967. It includes a 489ft tall guyed steel lattice mast, which was built in 1956. On top of the mast is located the UHF television transmitting antenna, which brings the overall height of the structure to 541ft.

9

SEASONAL SORTIES

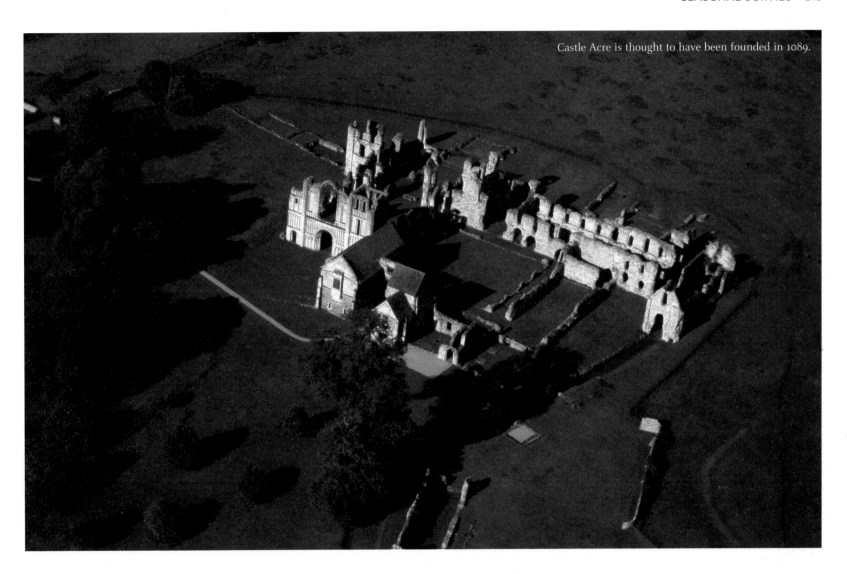

Castle Acre is thought to have been founded in 1089.

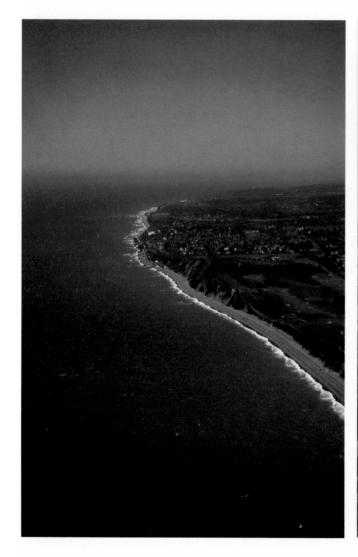

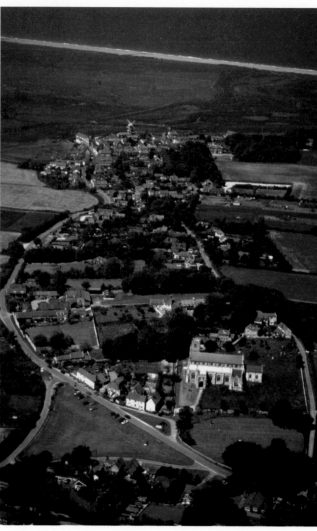

Far left: The coast at Sheringham and (*left*) Cley (pronounced 'Cly').

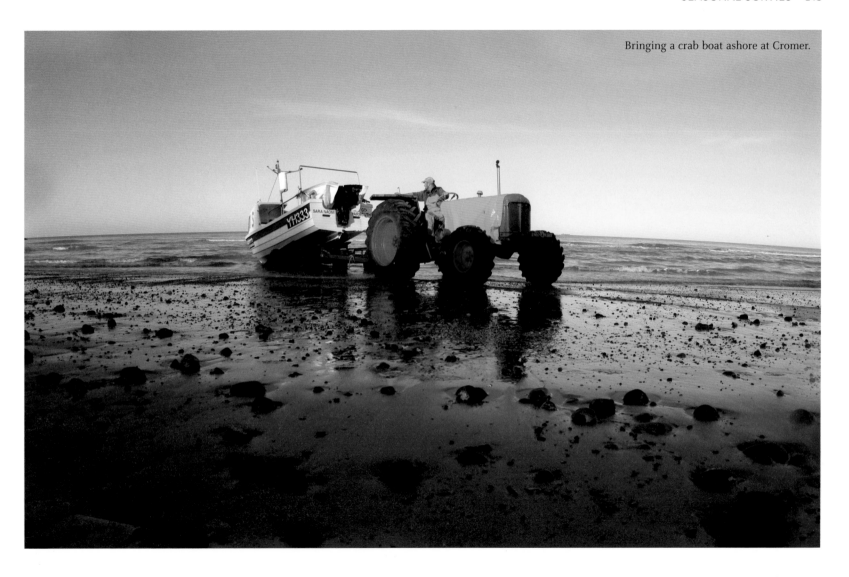

Bringing a crab boat ashore at Cromer.

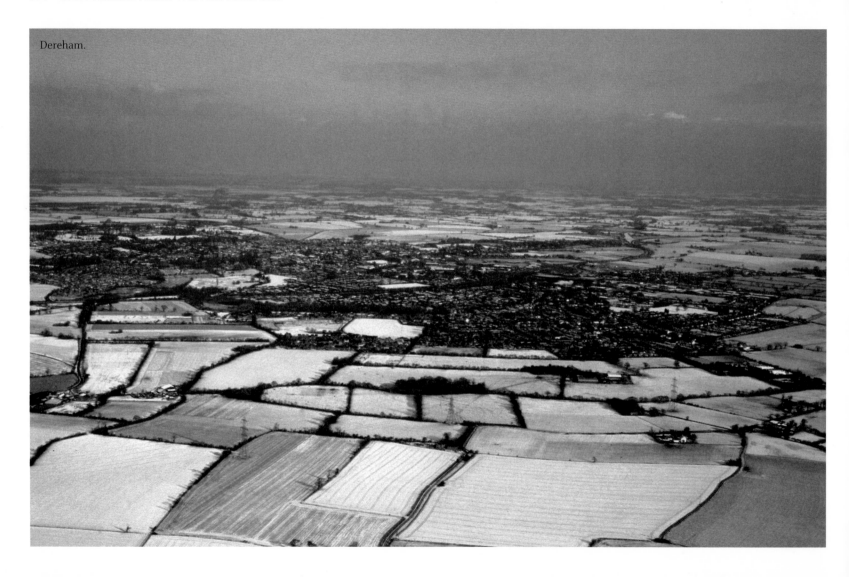

Dereham.

Dickleborough village in south Norfolk lies six miles north of the Suffolk border on the old Roman road to Caistor St Edmund, which was the main road until a bypass was built in the early 1990s.

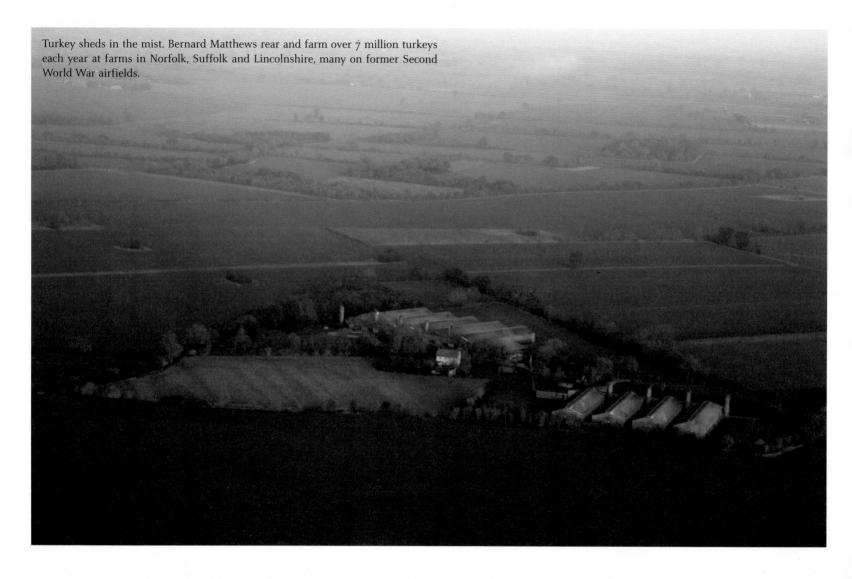

Turkey sheds in the mist. Bernard Matthews rear and farm over 7 million turkeys each year at farms in Norfolk, Suffolk and Lincolnshire, many on former Second World War airfields.

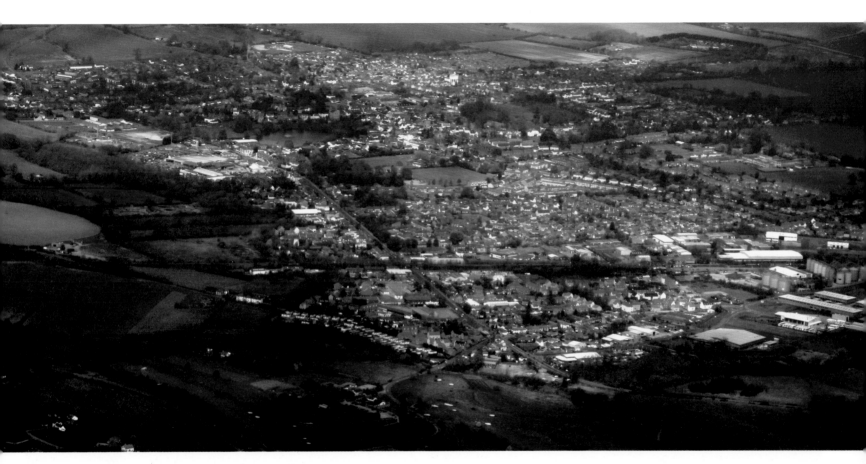

Diss.

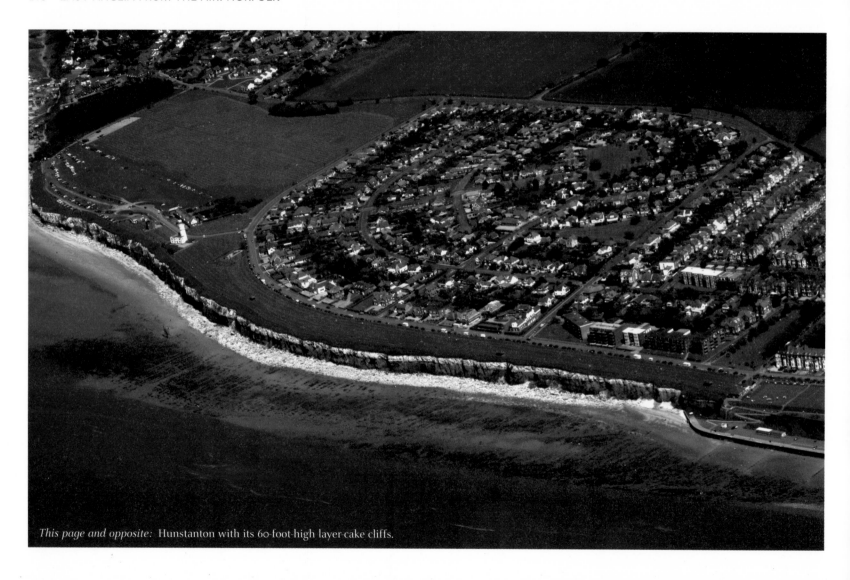

This page and opposite: Hunstanton with its 60-foot-high layer-cake cliffs.

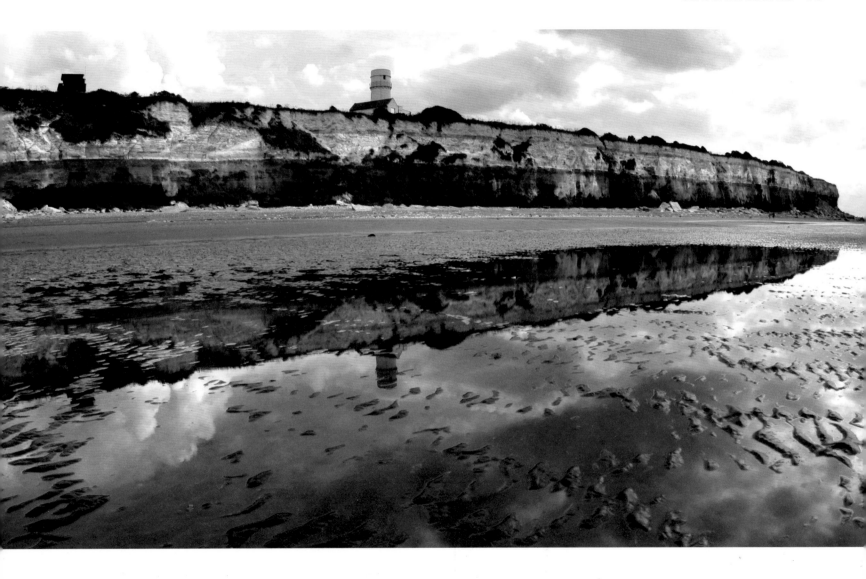

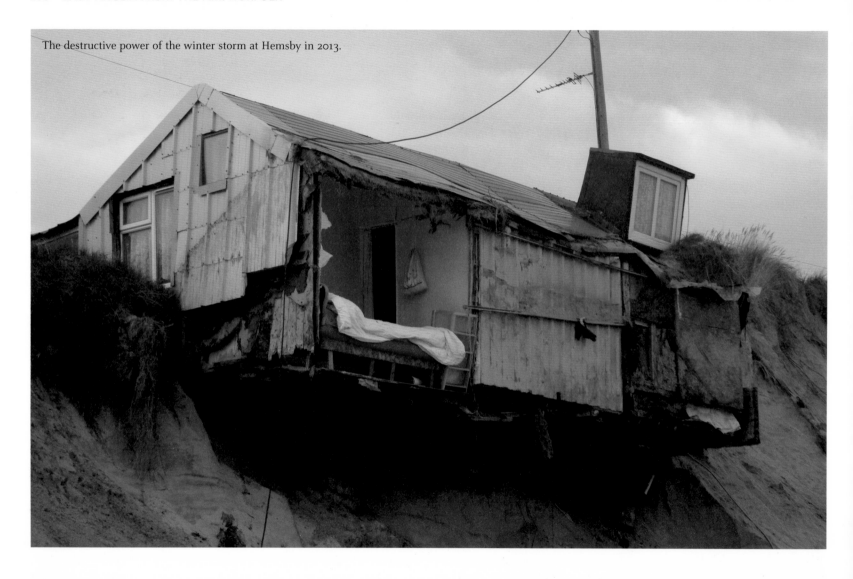

The destructive power of the winter storm at Hemsby in 2013.

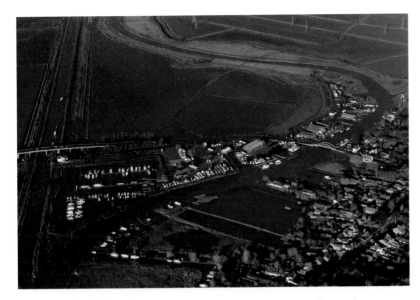

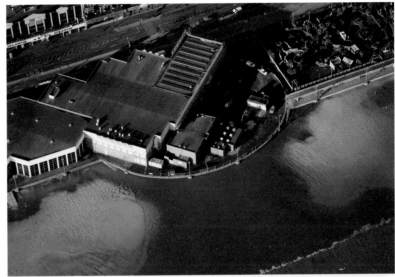

Above: Haddiscoe Island and St Olaves under floodwater. (*Mike Page*)
Above right: Yarmouth seafront under water. (*Mike Page*)
Right: Wrecked beach bungalows at Hemsby. (*Mike Page*)

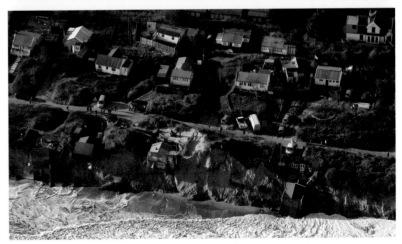

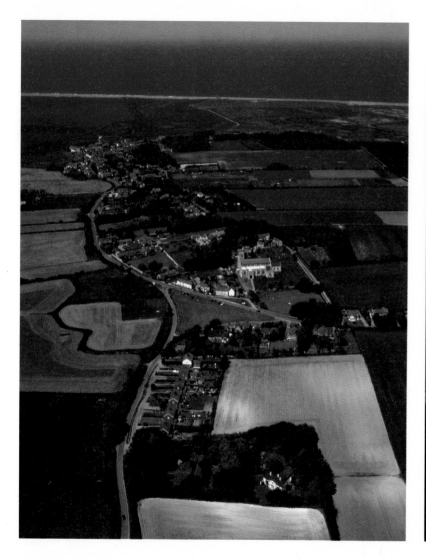

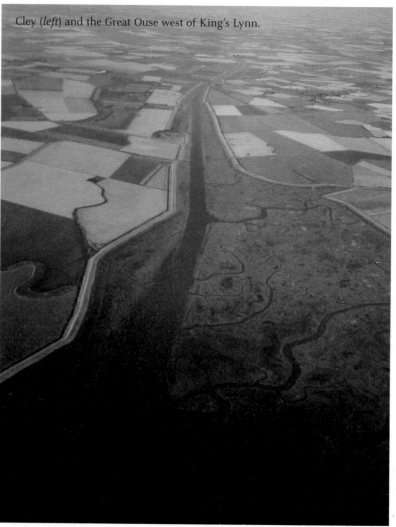

Cley (*left*) and the Great Ouse west of King's Lynn.

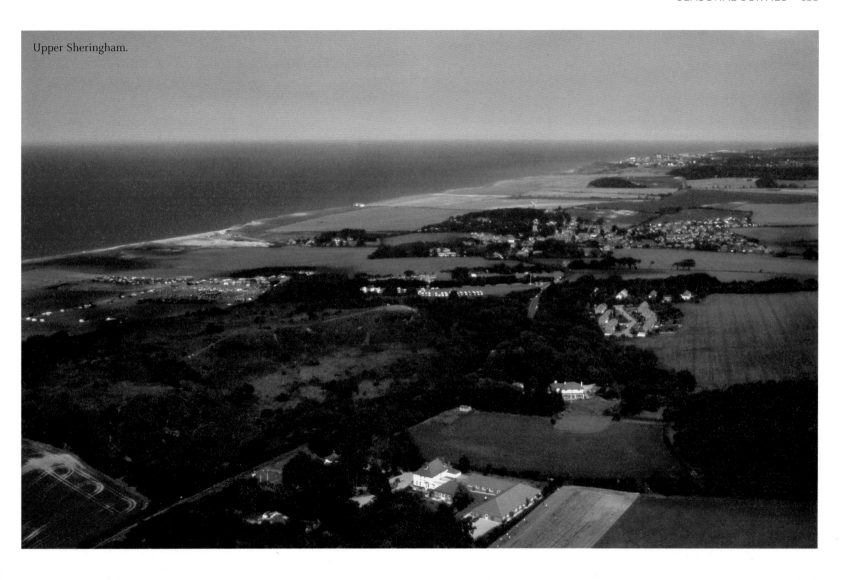

Upper Sheringham.

Long Stratton.

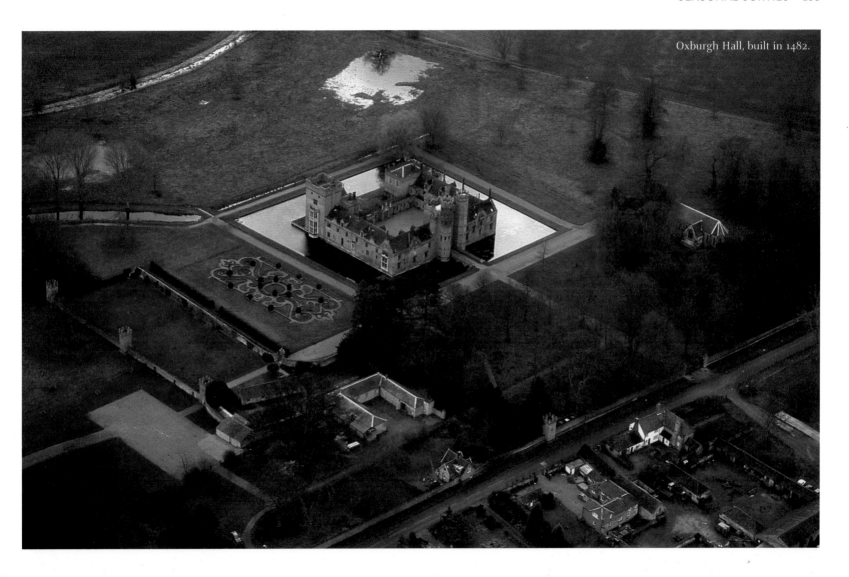

Oxburgh Hall, built in 1482.

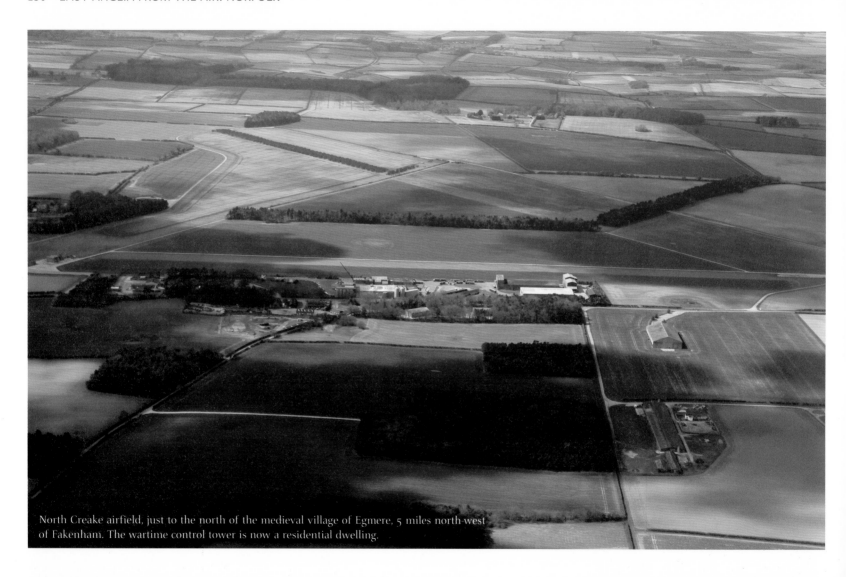

North Creake airfield, just to the north of the medieval village of Egmere, 5 miles north-west of Fakenham. The wartime control tower is now a residential dwelling.

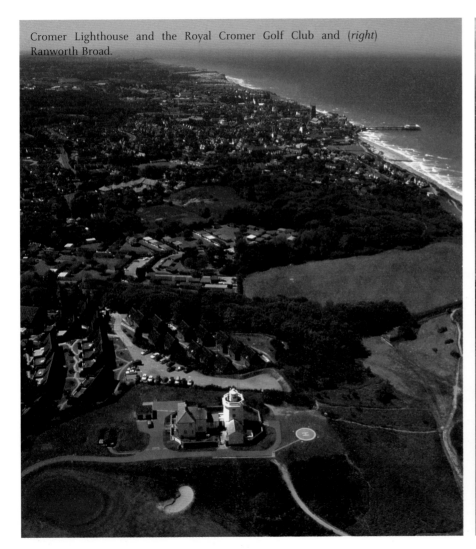

Cromer Lighthouse and the Royal Cromer Golf Club and (*right*) Ranworth Broad.

Reds.

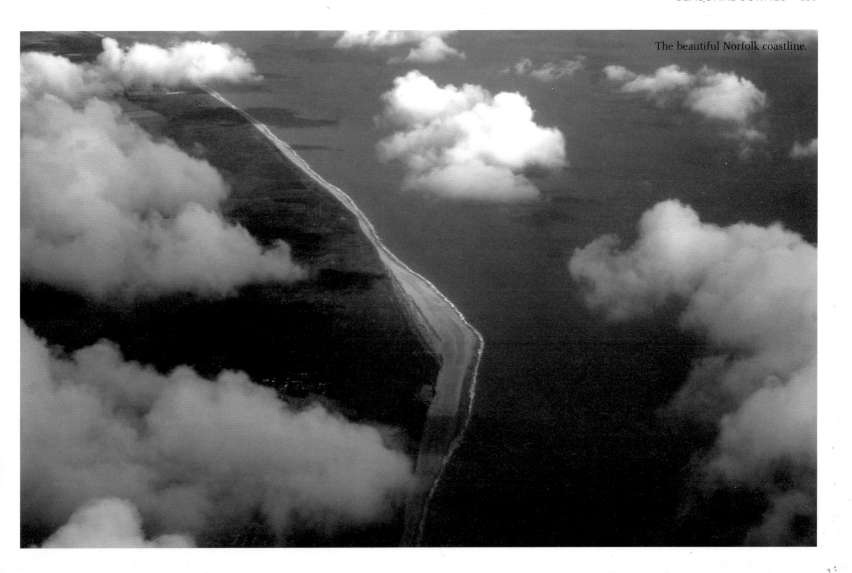

The beautiful Norfolk coastline.

Sunset at Old Buckenham airfield.